COLOR:
Essence and Logic

COLOR:
Essence and Logic

Rolf G. Kuehni

▣ **VAN NOSTRAND REINHOLD COMPANY**
New York Cincinnati Toronto London Melbourne

Printed in the United States
Designed by Iris Weinstein

Published by Van Nostrand Reinhold Company Inc.
135 West 50th Street
New York, New York 10020

Van Nostrand Reinhold
480 Latrobe Street
Melbourne, Victoria 3000, Australia

Van Nostrand Reinhold Company Limited
Molly Millars Lane
Wokingham, Berkshire RG11 2PY, England

16 15 14 13 12 11 10 9 8 7 6 5 4 3 2 1

Library of Congress Cataloging in Publication Data

Kuehni, Rolf G.
Color, essence and logic.

Bibliography: p. 131
Includes index.
1. Color 2. Color in art. I. Title.
ND1488.K83 1983 701'.8 82-24733
ISBN 0-442-24722-2

Contents

By convention there is color, by convention sweetness and bitterness, but in reality there are atoms and space.

Democritus (ca. 460 B.C. –ca. 400 B.C.)
Fragment 125

In his younger years the sixth Ch'an patriarch Hui-neng visited the Fa-hsing temple. He overheard a group of visitors arguing about a banner flapping in the wind. One declared: "The banner is moving". Another insisted: "No, it is the wind that is moving". Hui-neng could not contain himself and interrupted them: "You are both wrong. It is your mind that moves."

Tun-huang manuscript
Tenth century A.D.

Preface

Literature on the phenomenon of color, having grown considerably in recent years, consists mainly of either highly technical treatises on the quantitative aspects of color or books of advice to artists and craftsmen. The nonspecialist, curious about the subject, can be frightened away by the amount of mathematics and the heavy use of specialized terminology in standard technical works.

This book has been written for the interested layman, with the intention of providing a relatively simple but technically correct introduction to the scientific aspects of color. The author hopes to make a contribution toward bridging the communications gap between technically- and nontechnically-oriented people by providing a text for the latter that is completely nonmathematical and short, but reasonably comprehensive. The text, I hope, is interesting enough for artists, craftsmen, designers, and students of art and photography as well as for the layperson. You should come away thinking about and interested in the subject of color, which could be a steppingstone to more in-depth studies with more demanding texts.

I am indebted to my friends Max Saltzman, Ralph Stanziola, and Wolfgang Pester for reading the manuscript and making valuable suggestions for improvements. Shortcomings of the text must remain my responsibility, however. The editorial help from Ellen M. Fitzpatrick of Van Nostrand Reinhold Company Inc. and the work of Jim Shore in preparing the illustrations are appreciated.

Thanks are due also to Dr. David L. MacAdam, who made available to me the slide used in the production of Plate D.

R.G.K.
Charlotte, North Carolina
January 1983

1

What Is Color?

The question of the nature of color has puzzled humans since antiquity and has produced many and varied answers. Leaving the deepest (and unsolved) philosophical questions aside, the most obvious answer, one we do not have to think about very much, is that color is first and foremost an experience. It is an important part of what we experience when standing at the edge of Grand Canyon at sunset, when observing a rainbow against a thunderstorm-gray background, or when strolling through the permanent collection of the Museum of Modern Art, in New York. Color is a gift we have received to enhance our total experience of the world in which we live.[1] In a narrow sense color vision may have helped us to survive as a species; in a wider sense color represents much more than a simple aid to survival. Our (known) contacts with world and universe are by way of our senses. Persons with a normally functioning visual system obtain perhaps the largest amount of information about their surroundings from the visual sense and color plays a most important part in this flow of communication.

It is possible to think of humans as existing in three worlds.[2] In such a model World 1 consists of physical objects and states: nonliving and living natural objects and artificially created objects, as well as their physical states (gas, liquid, solid). World 2 consists of the states of our consciousness: our experiences of sensations, emotions, memories, and dreams as well as our thoughts and imaginations. This is the world in which we experience color. World 3 comprises our knowledge: philosophical, scientific, historical, artistic. Color also intrudes into this world, a world containing the theories we advance about the universe and our place in it, including the

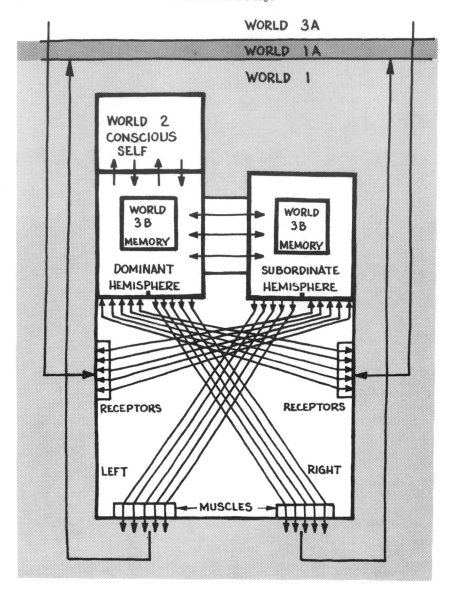

1.1. The three worlds of human beings (modified from Eccles, J.C., *The Understanding of the Brain,* **second edition, New York, New York: McGraw Hill Book Company, 1977):**
—World 1: physical objects and states
 (World 1A: "off line" storage of World 3, including books, documents, works of art, and so forth)
—World 2: states of consciousness (perception, thought, emotion, and so forth)
—World 3: knowledge in the objective sense
 (World 3A as contained in books, documents, and so forth)
 (World 3B as stored in memory)

theories of color vision. Figure 1-1 is a very schematic model of these three worlds and of the flow of information within and between them. The solid outline represents a human, the body itself being part of World 1 and receiving information through receptors from the rest of World 1 and from World 3. The brain, consisting of a dominant and a subordinate hemisphere, processes the information and guides the actions of the body via the muscles. World 2, the conscious self, the "I", is in this model an emanation of the dominant hemisphere.

The visual sense operates on several levels, like all other senses and functions of the human body. Or perhaps we should say that, in our efforts to distinguish and classify, we have established several conceptual levels of the visual system. There is the comparatively simple anatomical level, the sensory organ, the eye with its anatomical components, and the strands of nerve fibers connecting the eye in a complex pattern with what is called the primary visual cortex in the back of the brain.[3] There is the physiological level: the organic processes of the visual system, the absorption of light energy in the eye, and the transformation of this energy into nerve signals that are passed along to their final destination in the brain. There is the chemical level: the chemistry involved in the absorption of energy and the transmission of the resulting nerve signals to the brain. There is a physical level: the description of, interaction with objects of, and the fate of the energy arriving at the light-sensitive layer of the eye. There is the psychological level: the gross response of the organism to the absorbed light energy, the fact that we see an image of our surroundings that lets us function effectively in these surroundings. It includes the fact that certain absorbed energies under certain general conditions lead to sensations of red, blue, and so forth. There is, finally, an esthetic/ethical level: it relates to the effect certain absorbed energies have on our happiness and well-being.

While there are enough details available on all these areas to fill volumes, our real knowledge about the workings of the visual sense is quite limited. In particular, there is one substantial gap in our knowledge, namely, how at the end of the nerve pathway in the brain a "living," colorful picture of our surroundings is produced, making us conscious of these surroundings. And why do we respond with awe, boredom, enjoyment, disgust, or other emotions to certain combinations of absorbed energy?

It is appropriate here to proceed with a brief and simple description of the process of color vision as it is currently known. (Look to later chapters for more detailed explanations of many aspects.) Light consists of a particular kind of electromagnetic radiation.[4] The radiation, depending on its energy content, can exist as x-rays capable of passing through our body, can tan or burn us as ultraviolet radiation, is seen by us as light, can be felt by us as heat in the form of infrared radiation, and is used to transmit radio, television, and radar signals or for the purpose of transporting energy in the form of electricity. Electromagnetic radiation travels at high speed (the speed of light, approximately three-hundred-thousand kilometers per second). Our visual sensory organ, the eye, is sensitive to a narrow band of electromagnetic radiation, the visible spectrum.[5] Energy content of electromagnetic radiation is commonly expressed in terms of wavelength.

The basic nature of electromagnetic radiation and its mode of propa-

gation is uncertain. One view is that it travels in the form of waves (comparable to those created when throwing a pebble into a calm pond). The shorter the distance between neighboring peaks of waves (the wavelength), the higher the energy content of the radiation. Wavelength is commonly expressed in metric units and those of the light spectrum range, in round numbers, between four hundred and seven hundred nanometers (billionths of a meter). As mentioned, this band represents only a small portion of the total spectrum of electromagnetic radiation. Such radiation can, equally correctly, be thought of as traveling in individual packets of energy, called quanta. Energy quanta are also called photons.[6]

Electromagnetic radiation to which our eyes are sensitive is typically created by imparting energy (in the form of heat) to solid noncombustible materials until they begin to glow, i.e. shed energy in the form of photons. Such a stream of photons is called light. Electromagnetic radiation can interact with matter in various ways.[7] It can be absorbed by it (annihilated), or transmitted if the matter is transparent; it can change its direction by reflection or scattering on the surface of objects, or by changing from a transparent medium in which its speed is higher to another in which the speed is lower, or vice versa (refraction). It can also interact with itself by interference. In the process, the intensity of the radiation can be changed at some or all wavelengths. The electromagnetic radiation called light, as mentioned earlier, is normally produced by glowing matter: the sun, for example, or burning wax, or an electrically heated tungsten-metal coil. Glowing matter usually also produces ultraviolet and infrared radiation at the same time.

The radiation leaving the glowing body has certain quantitative and qualitative characteristics. The quantitative characteristics involve the amount or intensity of radiation, the qualitative aspects its wavelength.[8] If the radiation consists of rays of various wavelengths, it is of interest to know the relative intensity at various wavelengths, also called the relative spectral power distribution. The radiation streaming from the glowing material (or, the light) can be sampled directly with our eyes (burning candle, fluorescent or common light bulb) even though at times this is not advisable or is on occasion dangerous (sun, high intensity arc, and so forth).

More often than not, the energy beam streaming from the glowing material is modified by such processes (mentioned earlier) as reflection, transmission, absorption, refraction, and others before it reaches the eye. In other words, the light beam interacts in various ways with objects in its path (for example a person, a shelf of books, a bowl of fruit, a wall with a painting) and is in the process being modified before being sampled by the eye. A small portion of the light from the area we are gazing at enters the eye, is in the process being modified by the substances forming the eye, and reaches the light sensors at the back of the eye. There are basically two types of sensors present, the rods and the cones. If the conditions are such that only the rods are stimulated, the eye/brain system responds with sensations of light and dark only. The information obtained from rods is mainly used at low levels of light, at night, at late dusk, and at early dawn. The cones become active only at higher levels of light intensity. There are three types of cones, with different sensitivities across the light spectrum. In other words, a given intensity of radiation produces at most wavelengths a differ-

ent intensity of response in the three receptor types. These sensitivities are at present not known accurately. There are no generally accepted designations for the three types of cones, although, frequently, the letters P, D, and T are used as labels.[9] The response of the normal eye/brain system to the cone activities results in the sensations of light and dark as well as those of colors. Rods and cones are located in a layer of cells at the back of the eye, called the retina.[10] Their greatest density is in a central indentation of the retina, called the fovea,[11] the focus of the central portion of the light beam entering the eye.

The light-sensitive cells contain chemical substances undergoing changes under the influence of the absorbed light energy. They in turn cause electrical signals to be generated. These travel along nerve fibers to other cell layers. The signals travel, still in the retina, through a complex system of interrelated cells. While the structure of these cell layers is known in considerable detail, the purpose of each cell and the effect it has on the signal passing through remains largely a mystery. Long nerve fibers connect the retinal layer with the brain, and in the brain the visual signals pass through a number of waystations before they arrive at their (it is assumed) final destination in the visual cortex at the lower back of the head.

An unusual and largely unexplained fact is the separation of the signals generated in each eye along a vertical axis so that all information from the right side of our field of view from both eyes arrives in the left half of the brain and vice versa. While it has been well established that information processing at the highest level is different in the two halves of the brain, it is unclear how this relates to the fact that all the information from the right side of the visual field ends up in the left lobe of the brain, and vice versa.

The general sequence of events is not unlike that in a television system, in which the light rays enter the camera through an optical lens and form a detailed but reduced-in-size image on the light sensitive surface inside the camera. There, the light intensities are converted to electrical signals in a mosaiclike fashion, i.e. the seamless original image is broken up into a finite number of separate dots.

Signals containing information about the quantity of light (and perhaps its quality) at each dot are passed through a more or less elaborate system (short circuit, via satellite) to the receiver, where the image is recreated by reproducing the dots in the same mosaiclike pattern. By keeping the size of the dots small enough so that that they cannot be seen individually, a reasonably faithful copy of the original image can be achieved. A television system resembles the visual system only in a coarse way. But also in the visual system the optically projected image of what is in front of the lens, i.e. what we see, is broken up into dots by the individual rods and cones. Signals representing these dots are processed in a complex manner and passed through to the brain to form a duplicate image (of sorts) in nerve cells in the visual cortex.

Space as well as time imposes various and complicated limitations and effects on the signals. The space limitations have to do with the imperfect optics of the eye as well as the irregular distribution throughout the retina of the rods and cones. For example, the central area of the fovea is believed to be largely blue-blind, presumably because the corresponding

cone type is missing there. The temporal limitations have to do with the fact that many of the chemical and physical processes on the way from eye to brain are not instantaneous and do not occur at the speed of light. For example, when a disk containing variously colored sectors is spun at a certain speed, the individual sectors do not create separate color sensations anymore but rather a new, combined color sensation. These limitations become noticeable under certain conditions.

Modern scientific techniques can trace the signals from the retina to the visual area of the brain.[12] But the next step remains mysterious: the map of signals in the form of electrical nerve potentials in both the left and right halves of the brain is converted into a "living," colorful, three-dimensional perception of "what's out front". Most of the information produced by the visual system never reaches the level of our consciousness, but the system is ready during waking hours to supply information to the conscious "I" at an instant's notice.

We normally see colors as a result of the impact of light rays on the light-sensitive receptor cells in the retina. There are, however, ways of creating the sensation of color in the dark, with our eyes closed:

—under the influence of migraine headaches[13]
—under the influence of certain drugs[14]
—by direct electrical stimulation of certain cells in the visual center of the brain[15]
—by pressing the eyeballs
—by hitting one of the temples moderately hard
—by dreaming.

In some manner, these actions or situations trigger responses in the visual system of the brain and lead to some of the same results as those caused by stimulation of cones in the retina by photons. This is a situation not unlike that of an electronic burglar alarm being triggered by an airplane flying overhead as well as by a burglar. These and possibly other methods of producing color sensations without light make it clear that perception of color is a phenomenon of human beings (or other animals). It can be, and normally is, produced under the influence of light rays, but they are not essential for color sensation. Lights and objects in front of us are, therefore, not colored, they only differ in spectral composition, respectively reflecting properties. The situation can be loosely compared to so-called false-color images, beautiful and stirring examples of which have been produced from space satellite sensor data of such objects as the earth and the planet Jupiter. In these pictures pieces of spectral data not of the visible band, obtained by pointing a sensor at the object, are transformed into a colored image in such a way that certain colors represent certain nonvisible spectral bands. The purpose of translating the data into color stimuli is to display the data from the sensor in such a way as to create maximum information for our perceptive system.[16] In the sense of a picture being worth a thousand words, a false color picture of some natural phenomena for which we have no sensory organ is priceless, even without consideration of esthetics. The information content of a black and white image is vastly enhanced by the inser-

tion of colors. Without colors the image represents intensities only and appears in white, black and in shades of gray. Colors add a considerable number of qualities, theoretically as many as the number of colors we can distinguish. The survival value of such a system for our species in terms of food and security is obvious and undeniable.

Colors, as mentioned before, are not real, and the world in front of us is not colored. Our brain creates the sensations of colors, most often from certain quantities and qualities of electromagnetic radiation which strike our sensory organ. This is an explanation that is not easy to accept at first. Are not flowers and many other materials naturally colored, and can we not color others with the use of dyes or pigments? Dyes and pigments are often informally and confusingly called colors because they seem to be the causes of color. What they accomplish is a modulation of light waves, an interaction with them, so that the reflected waves have the energy levels necessary to produce a color sensation in the brain after absorption by the cone cells of the retina.

Color, to reiterate, is an experience, poetically speaking a flower of our brain activity. Not only does it provide vital information about our surroundings, but like the effluences of our other senses it gives us considerable pleasure. To be able to use our color sense to its best advantage in the visual arts, in clothing, external architecture, and interior architecture is one of the distinctive features of humankind. That colors should play important roles, especially in the more distant past, in myths, religions, and rituals is a development that has its parallels in the sensation of sound. These and other instances indicate that our most important sensory channels are used by us to help express our understanding of our place in the universe.

The definition of color as an "experience" or a "flower of our brain activity" is quite obviously not satisfactory for specific purposes. Scientists, uneasy with color as a perception, confess their helplessness by providing a circular definition of color as a perception: "perceived color is the attribute of visual perception that can be described by color names: White, Gray, Black, Yellow, Orange, Brown, Red, Green, Blue, Purple, and so on or by combinations of such names".[17] The same problem exists, of course, in defining any other of our sensations, emotions, or feelings. What is sweet, what is happy?

Scientists find it much easier to define "psychophysical color." This is a term essentially describing the stimulus, typically the stimulus as it exists after initial absorption of the photons by the receptor cells. It is defined as "Characteristics of a color stimulus consisting of three values such as three tristimulus values".[18] It is clear, however, that the scientific treatment of color as a phenomenon has considerable limitations.

It would appear obvious that there is nothing measurable in an experience such as color as there is nothing measurable in our experience of listening to a piano sonata being performed. But what about pitch, intensity, frequency of sound waves, harmonic distortion, and so forth? We can measure various aspects of a visual stimulus, i.e. of a light beam entering the eye or of the modulation and interaction of the beam with materials on its way from its source to the retina.[19] It should be noted that such instrumental measurements relate to the stimulus only and not to the response it causes.

They have meaning in terms of the response (the sensation of color) only if there is a known relationship between stimulus and response. Whether or not the response can be measured is a question in dispute. Nevertheless, scales of color attributes, such as brightness, saturation, and chromaticness, have been established. While measurement of the stimulus is a province of physics, the measurement of the response belongs to psychology.

The relationship between stimulus and response touches on the problem of measurement, which is a science by itself with its own problems and difficulties.[20] Measurement is agreed to consist of assigning numbers to objects or certain events according to consistent rules. Depending on these rules, scales with definite mathematical properties result (such as in measuring distance or temperature). In other cases no solid mathematical relationships can be found (such as in measuring sweetness, pain, or intensity of color). There is, as mentioned, the fundamental question of whether sensory magnitudes can be measured at all, and if they can be, what exactly the measurements would mean. It is well known that scales of a particular attribute derived by different procedures frequently are not the same, and that relations found to exist at the threshold of a sensory response can differ from other relations at higher levels of response.

There are four basic types of scales:

a. *Nominal scales*. Such scales determine whether or not two things are equal. An example of a nominal scale is the numbers printed on the uniforms of basketball players. The sequence of the numbers does not have any meaning and they serve only to distinguish the players.

b. *Ordinal scales*. In addition to establishing equality, these scales also determine the order of things. An example is the pecking order among chickens. Number 1 is the leading chicken, while number 17 has less influence on its peers.

c. *Interval scales*. In addition to addressing equality and order, this scale also determines the quality of intervals on the scale. A typical example is the Celsius scale of temperature. While the interval between 20°C and 30°C and that between 70° and 80°C is the same, it cannot at the same time be said that 50°C is twice that of 25°C, since the scale does not start at the zero point of temperature. In the color field a color-difference scale is a typical example of an interval scale (see Chapter 5).

d. *Ratio scales*. In addition to the foregoing, a ratio scale determines the equality of magnitudes. A very common example is a distance scale, such as length in meters. A distance of 20m is twice as long as one of 10m. A brightness scale (see Chapter 4) is an example of such a scale from the color field.

We need to distinguish between subjective scales and objective scales. The subjective scales are those having to do with sensations of an individual or of the average person. In the case of color they are psychological, sensory scales of certain aspects of color such as hue, brightness, saturation, color difference, and so forth.[21] They do not involve stimulus quantification (instrumental measurements of light intensities). A typical example is a gray scale, a series of gray samples perceived under standard

viewing conditions to have identical intervals between steps. A well-known example of a gray scale can be found in the *Munsell Book of Colors*.[22] There, aside from lightness, two other sensory attributes of color, hue and chroma, have been scaled.

Objective scales are based on instrumental quantification (such as a temperature measurement). Since color is a human experience, objective scales of color are not really possible. The dilemma has been solved by linking the objective stimulus measurement with the subjective color experience. For this reason the resulting scales all have the prefix psycho- attached as a warning that they are not "pure" but involve the senses. There are three types of such "psycho-objective" scales in use or under development in the color field:

Psychophysical Scales. These are nominal scales containing the least amount of the subjective, the sensorial. Examples are tristimulus values.[23] Such scales have no simple relation to visual responses with which they are associated. That is, equal intervals on a scale are not related to equal intervals in visual response; they merely indicate that stimuli resulting in identical scale values produce identical sensations under standard conditions.

Psychometric Scales. These are interval scales expressing the instrumentally measured stimulus in terms of the average visual response under standard conditions. Examples are metric lightness, metric chroma, metric hue difference, and so forth.[24] They are based on instrumental measurements the results of which are modified by mathematical formulas. The mathematical scales resulting from application of the formulas are rigorous, but the correlation with the average visual response is for a number of reasons often less than satisfactory. A very important reason is that the visual responses have not been studied nearly as diligently as necessary. The limited success of applying psychometric scales may be due in part to the complexity of the visual system, but the fact that mapping of visual responses is incomplete in scope and insufficient in depth remains primary.

Psychoquantitative Scales. These are ratio scales expressing the stimulus in terms of the average visual response so that not just intervals of the scale but also ratios are comparable. They are absolute scales starting with zero response and proceeding to maximum response. Examples are quantitative brightness, quantitative saturation, quantitative blackness, and so forth. A quantitative blackness scale starts at white (zero blackness) and proceeds to black (maximum blackness). The scale is arranged in such a way that, perceptually, not only the distance between colors with blacknesses 3 and 4 is the same as that between colors of blacknesses 7 and 8, but that a color with blackness 8 is twice as black as one with blackness 4. Such scales are still largely under development and represent one frontier of color measurement.

The reason for color measurement, aside from scientific curiosity, is economic, the purpose being to predict what the average person (the customer) will see when contemplating a purchase. What color science hopes

to do is predict the average sensation resulting from a certain stimulus under given conditions. To predict the associated perceptions would seem impossible. In its ability to predict sensations color science is currently still in a child's age. Substantial efforts are necessary to quantify average sensations. With the help of such added data and on the basis of additional needed information on the physiological nature of vision, it may become possible to build better mathematical models of the visual system to allow more accurate predictions of average sensations resulting from a given stimulus.

Color science has had its greatest success in predicting the equality of sensations resulting from two different stimuli. As we will see later, it is possible for two physically different stimuli to produce the same sensation. The prediction of equality is a part of what is often referred to as *basic* or *fundamental colorimetry*, and involves nominal scales. *Higher* or *advanced colorimetry*[25] deals with color differences and other complex color phenomena involving interval and ratio scales.

A particular problem of applied color science today is that instrumental technology has reached remarkable heights with optics and electronics. No comparably rapid advances have been made in the quantification of average sensations. The user of instrumental, particularly computerized, systems is often impressed by the speed of their operation and degree of automation, tends to forget the tentative nature of much of the psychological principles and data used to arrive at the answers, and takes the output of the computerized system as absolutely factual. For this reason it is useful to understand the limitations of current knowledge of the relationship between stimulus and response and to maintain a healthy skepticism regarding the results of the calculations. One of few undisputed facts is that the visual system is enormously complex. Aside from the basic complexity of the system there are always noticeable differences between the responses of the visual apparatus of individuals. Such differences (excluding abnormality of color vision) can also be shown to exist within an individual as a function of time. They limit the accuracy of color measurement considerably in the sense that individual visual response cannot accurately be predicted. In addition, measuring instruments are usually limited to measurement under one set of conditions, corresponding to one specific viewing situation for an observer. The eye, on the other hand, roams freely over the scene, integrating results from many viewing angles and considering additional aspects of appearance, such as gloss. This difference can result in disagreements between instrumental and visual evaluation.

Despite all these (and some are undoubtedly serious) limitations, color measurement is having remarkable success in industries producing or using colorants (dyes, pigments). Color reproduction is probably the one most important field. To reproduce the perceived color of objects or to produce an object that, when viewed, results in a desired color sensation is an old and tantalizing problem of art, design, and coloring technology. As an example, consider the problems associated with the reproduction of the image of a peach in a still life. Color reproduction in graphic color prints, color film, and color television as well as colorant formulation of dyes and pigments for various materials have all benefited considerably from the application of

color theory and measurement, making possible more accurate reproduction of originals and better repeating results from batch to batch in manufacturing of colored goods. Other areas of application of color science are quality control of colored goods, and the designing of lamps that are energy conserving and render perceived colors of objects similarly to daylight and so forth. Artists, designers, and craftspeople obviously do not need to know color science in order to produce masterpieces. What they are required to know about the results of mixing pigments or dyes can be learned by experience, even though a systematic approach based on color science may be useful. It is also useful to understand the color constancy properties[26] of colorants and the effect of various light sources on perceived colors. The problem of control of the effect of one colored field on the perceived color of another, neighboring one (see Plate B for an example) seems to require intuitive solution by the artist and is one of the abilities required of an artist. The same applies to the techniques needed to create realistic impressions of given objects on canvas or paper. However, if the artist or designer becomes involved in photographic or graphic reproduction of a work, knowledge of color science would seem necessary for obtaining good results quickly and confidently.

Similarly, the photographer and filmmaker working in color can learn the relationships between light source, object, filter, and film characteristics by trial and error, or can avail himself of the storehouse of information available in color science to predict the results more quickly and confidently.

Color measurement and color science provide tools that aid in predicting, in some cases quite accurately in others only approximately, what the color sensations of the average observer will be in response to a given light stimulus or what light stimulus is required to produce a certain sensation. They are imperfect tools but nevertheless highly useful. They cannot and do not claim to say everything about the phenomenon of color and its meaning for an individual.

Footnotes

1. Despite superficial appearances to the contrary, color, as we will see, is not a property of materials or of lights. Our everyday terminology often indicates the opposite (The color of the sweater is blue. When the color of the light turns red you must stop. More color was added and painting began.) but is simply erroneous. People familiar with the facts know that normal usage of color terminology is but convenient double talk borne of habit, while others use it out of ignorance. Since it has persisted for centuries, it is unlikely to change.

2. The three-world model has been proposed by Sir Karl Popper (see e.g. Eccles, J.C., *The Understanding of the Brain*, second edition, New York, New York: McGraw Hill Book Company, 1977).

3. The cortex (Latin, meaning *bark*) is the outer layer of gray matter of the brain.

4. *Electromagnetic radiation* is a convenient name for the phenomenon of energy transport, the fundamental nature of which remains obscure.

5. A spectrum, (Latin, meaning *appearance*) is an array of components of electromagnetic radiation arranged in order of some varying characteristic, such as wavelength.

6. The words quantum and quanta are from Latin *quantus*, meaning *how much*; a quantum is an increment of energy. *Photon* is from the Greek *phos*, meaning *light*. It was originally used to denote a unit of light energy but is used today to indicate the standard unit of electromagnetic

energy. The exact nature of photons is uncertain. They are fundamental particles having no electric charge. They are the basis of controversy between the wave theory and the corpuscular theory of light, both of which can be supported by experiment. It is impossible to determine the location of a photon at a given point in time except on a statistical basis (see e.g. Sears, F.W.; Zemansky, M.W.; and Young, H.D., *College Physics*, fifth edition, Reading, Massachusetts: Addison-Wesley, 1980).

7. For a more detailed description of the processes that follow, see Chapter 2.

8. Think of the quantitative characteristics as being the number of animals in a zoo and the qualitative aspects as being the types of animals there.

9. *P*, *D*, and *T* are borrowed from the Greek *protos* meaning *first*; *deutos*, meaning *second*; and *tritos*, meaning *third*.

10. *Retina* is probably from *rete*, the Latin word meaning *net*.

11. *Fovea* is from the Latin, meaning *pit*.

12. See Hubel, D.H., and Wiesel, T.N., "Brain Mechanisms of Vision," *Scientific American* 241 (1979), No.3 (September), pp. 150-163.

13. See Richards, W., "The Fortification Illusions of Migraines," *Scientific American* 224:13 (May 1971), pp. 88-94.

14. See e.g. Huxley, A., *The Doors of Perception*, London: Chatto & Windus, 1954.

15. See Brindley, G.S. and Lewin, W.S., "The Sensations Produced by Electrical Stimulation of the Visual Cortex," *Journal of Physiology* 196 (1968), pp. 479-493.

16. Here is as good an opportunity as any to discuss the difference between sensation and perception. Sensation is preceded by stimulation and followed by perception. Sensation and perception are the responses to the stimulus (from the Latin, meaning *goad*). Sensations traditionally refer to immediate experiences or attributes such as bright, red, saturated, and so forth. Perception, on the other hand, implies more complex psychological processes involving memory, judgment, meaning, and experience. Consider the sensation and perception resulting from hitting your finger with a hammer.

17. This definition of color as an experience is from an official proposal for a revision of the definition in the *International Lighting Vocabulary*, third edition, Publication CIE No. 17, 1970. The definition it is intended to replace is as follows: "Color: aspect of visual perception by which an observer may distinguish differences between two fields of view of the same size, shape, and structure, such as may be caused by differences in the spectral compositions of the radiation concerned in the observation."

18. See Chapter 6 for an explanation of this definition for psychophysical color.

19. In that sense, the term *color measurement* is a misnomer, since color as a sensation cannot be measured instrumentally but only in the sense of psychological scaling with a person being the measuring instrument. What can be measured in the conventional sense are aspects of the stimulus. The quantified stimulus can then be related to the average perceptual response under standard conditions. Nevertheless, *color measurement* is a commonly and widely used term for stimulus measurement.

20. A full discussion of measurement is beyond the scope of this book.

21. For the definition of these terms see Chapter 3.

22. For a description of the Munsell color order system, exemplified in the *Munsell Book of Colors*, see Chapter 5.

23. For a definition see Chapter 6.

24. See Hunt, R.W.G., "The Specification of Colour Appearance. I. Concepts and Terms," *Color Research and Application* 2 (1977), pp. 55-68.

25. See Schrödinger, E., "Grundlinien einer Theorie der Farbenmetrik im Tagessehen," *Annalen der Physik* 63, (1920) pp. 397-444, 481-520; translated as "Outline of a Theory of Color Measurement for Daylight Vision" in MacAdam, D.L., editor, *Sources of Color Science*, Cambridge, Massachusetts: The MIT Press, 1970.

26. For a discussion of color constancy see Chapter 3.

2

Sources of Color

One of the most impressive displays of color occurs when a narrow beam of sunlight passes through a glass prism (see Plate A). What leaves the prism on the other side is the same beam as enters it. But upon leaving the prism it is in the form of a stretched-out band that when reflected from a white surface produces in the observer's eye/brain system a multitude of color sensations: the colors known as those of the rainbow. The prism effect is one of the better known sources of color and is called refraction. There is a considerable number of natural processes resulting in stimuli that produce color sensations under normal circumstances. It is not surprising, then, that the identification and analysis of these processes has literally taken centuries. Artisans and technicians over the course of millennia have by trial and error found processes leading to color sensations but the underlying causes of the sensations were identified only much later. Natural and artificial materials appearing colored (many of them used as colorants) are commonly thought to interact in a similar way with electromagnetic radiation, but their apparent color is in fact caused by a wide variety of specific phenomena.

Incandescence

Incandescence is the emission of electromagnetic radiation by a hot body, producing light that can give rise to color sensations.[1] The dominant example of an incandescent body is the sun. But the nature of incandescence is most easily observed during a visit to a blacksmith. An iron rod or a horse shoe placed into an intense coal fire will as it heats up assume a dull red glow. If we view it in the dark, we recognize it as a source of reddish light. As the temperature of the iron increases, so does the quantity of emitted light, or the glow. Simultaneously, as the reddishness diminishes the object becomes "white-hot" and eventually assumes a bluish-white appearance. The mechanism involved is one of absorption of electromagnetic energy (by the iron from the coalfire) and emission of energy in a changed form as photons (the light emitted by the glowing iron). The energy can have many sources: thermonuclear, as in the case of the sun; electrical, as in the case of a lightbulb; chemical, as in the burning of coal; or light, as in the case of a laser. All chemical elements can under proper conditions be made to show incandescence, as can many inorganic molecules. Organic molecules (those containing carbon) have only a limited capability of absorbing energy and are generally destroyed, except for carbon itself, before they show incandescence.

The form of the material is important to its incandescence: while substances in gaseous form emit energy in one or more distinct and narrow bands, liquids and (even more so) solids emit energy across broad spectrum bands. Figure 2-1 is a schematic representation of the complete electromagnetic spectrum, in which light occupies only a narrow band. Note that the energy level can be expressed in at least two ways, in wavelength and in number of electron volts.[2]

How can energy absorption and incandescence be explained? The accepted theory is based on an atomic model, with protons and neutrons in the central nucleus and electrons located in various shells around the nucleus. Each of the shells has a limited number of spaces for electrons that depends on the atom involved. Shells filled to their limits or in which electrons are present in pairs are in a relatively stable configuration. Electrons in the outermost shell, especially single ones, are fairly easily dislodged. If dislodging occurs the atom is said to be ionized. It is then ready to undergo chemical reaction with ions of the opposite electrical nature. Before the electron is lost or before ionization occurs, the atom or molecule goes through stages of excitation. Each stage involves the electron(s) in the outermost shell and can be visualized as rungs on a ladder (the rungs on the excitation ladder are not equally spaced, however). Absorption of a specific amount of energy will raise the excitable outer electron to the next rung on the excitation ladder. According to quantum physics,[3] matter can absorb energy only in such distinct steps, not continuously. After the top rung is reached, the electron disengages itself from the atom and the atom (or molecule) is then ionized. At any given time the assembly of atoms or molecules in matter is

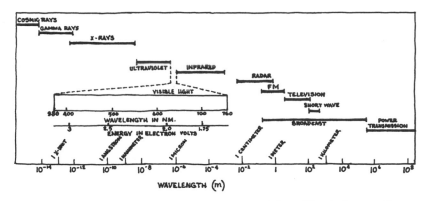

WAVELENGTH (m)

2-1. A schematic representation of the electromagnetic spectrum.

not only absorbing energy but is also shedding it: while in certain individual atoms the outer electrons are raised to a higher energy shell due to energy absorption, in other atoms they fall back, according to their natural tendency, to a lower shell in order to be in energy equilibrium with their surroundings. The energy is being shed in form of packets or quanta, also called photons. If the energy is such that it falls between approximately 400nm (nanometers) and 700nm, the quanta can be sensed as light. If they have other energy levels, they fall into another area of the electromagnetic spectrum such as the ultraviolet or infrared band. When energy is shed in form of photons, the excited outer electron falls successively back to lower energy shells until it returns to its original position.

There is a large number of possible rungs on the energy ladder, and when energy is shed the electron can cascade backward in a variety of ways, all of which follow certain rules. In the case of gases there are statistically preferred paths of the cascade leading to narrow bands of emitted light if the quanta have the proper energy level to be visible. Examples of elements emitting most energy as gas in a few narrow bands are:

Substance	Wavelengths of important emission, in nanometers	Color
sodium	589, 590	yellow
lithium	610, 670	red
lead	406	blue
barium	553, 614	green

In the case of incendescent solid substances, the quanta from various individual atoms or molecules have widely varying energy levels, leading to continuous energy distributions of the emitted quanta. It should be recognized that such continuous energy distributions represent the statistical averages of all specific energy quanta being shed at a given time by individual atoms or molecules. Figure 2-2 is a hypothetical and schematic represen-

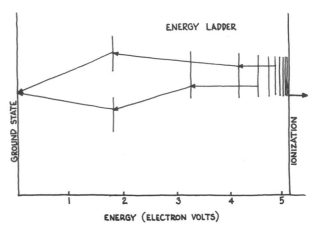

2-2. A schematic and hypothetical representation of the energy ladder of an atom.

tation of an energy ladder of an atom. The case illustrated results in two major energy levels of electrons cascading to the original or ground state producing two distinct emission bands. The amount and the energy distribution of emitted radiation are functions of the temperature. Emission ceases completely only in the vicinity of the lowest temperature possible, i.e. 0° Kelvin.[4] In order to produce light, the temperature of the emitting material usually must be above 1000°K.

Black Body Radiation

A black body is a nonexistent idealized material that is a perfect absorber and a perfect emitter. That is, it absorbs and emits energy indiscriminately at all wavelengths. The emission of such a body at a given temperature can be calculated on a theoretical basis. Examples of black body emissions are illustrated in Figure 2-3. Many real substances produce an emission spectrum quite close to that of a black body. The black body temperature, expressed in degrees Kelvin on the absolute scale, is in turn routinely used to qualitatively classify the emission behavior of a light source even if the emission behavior is unlike that of a black body. Thus, light sources are classified by their correlated color temperature. Figure 2-3 also indicates that the emission spectrum of the sun as measured on earth quite closely resembles that of a black body at approximately 6000°K. It indicates further that the brightness sensitivity of the human visual system is tuned to the emission spectrum of the sun.

 To return to our example of the blacksmith and stating that, at least at higher temperatures, the emission of iron is reasonably close to that of a black body, the apparent change in color at increasing temperatures can now be explained in terms of the emission spectrum, as illustrated in Figure

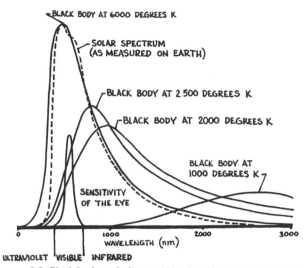

2-3. Black-body emission spectra at various temperatures (in degrees Kelvin), the solar spectrum as measured on the surface of the earth (dashed line), and the brightness sensitivity of the human visual system.

2-3. The coal of the fire surrounding the iron radiates similarly to a black body at a temperature of about 1800°K. Another light source, the common lightbulb (in which a tungsten wire is made to glow by the resistance to the flow of an electrical current) also has an emission spectrum close to that of a black body. Lightbulbs are typically operated at 2500°K with an approximate emission spectrum as illustrated in Figure 2-3. It is evident that a tungsten lightbulb does not make efficient use of energy, since most of the radiation emitted is not visible. Lightbulbs become very hot during operation because most of the emitted energy is in the infrared region, and we sense that energy as heat. Fluorescent lamps, on the other hand, emit most of their energy in the visible spectrum, operate cooler, and are more energy efficient. Black bodies at temperatures between approximately 2500°K and higher emit light that, especially after adaptation (see Chapter 3), is seen as white. The sensation caused by "white" light, or light in its most inconspicuous form, may well be our response to the pervasive presence of daylight in our life. The sensation of white is caused by all those stimuli having a similar effect on our visual apparatus as daylight.

Luminescence

The creation of light is also possible by processes not based on the absorption of heat. This phenomenon is called luminescence. There are three basic processes being distinguished: electroluminescence, chemiluminescence, and photoluminescence.

Electroluminescence is typified by arcs, sparks, lightning, some laser energy, and gas discharges. Under the influence of an electric field, electrons collide with particles of matter leading to the emission of photons of the proper energy level to be sensed in the eye as light. Chemiluminescence is produced by chemical reactions, mainly oxidations, at low temperatures. Natural chemiluminescence, also called bioluminescence, can be observed in glow worms, fireflies, and certain deep-sea fish and on decaying wood or putrefied meat. Chemiluminescence is represented in commercial form by a type of emergency light stick marketed in this country. Photoluminescence has two forms: fluorescence and phosphorescence. It is based on the unusual properties of certain molecules to absorb energy (either near-ultraviolet or visible), and shed it not in form of infrared radiation, as most absorbers of visible energy do, but in form of visible radiation of a somewhat lower energy content (therefore higher wavelength). Thus fluorescent whitening agents absorb ultraviolet radiation of 300nm to 400nm wavelength and emit visible radiation at 400nm to 480nm. Fluorescent colorants (also see Chapter 8) absorb and emit visible energy; for example a fluorescent red absorbs light from about 450nm to 550nm and emits light at 600nm to 700nm. Fluorescent colorants appear to glow because of the emission of light, but they are actually rather weak emitters of light. There is also a number of inorganic materials that fluoresce. Examples can be found in some rock formations. The term *fluorescence* is applied in those cases where the emission of light stops essentially as soon as the absorbed energy is interrupted. Some substances (like phosphor) are capable of storing the absorbed energy for a time. They continue to emit light for some time after the exciting energy is stopped. This is called phosphorescence.

Absorption, Reflection, and Scattering

The fate of light on its path from creation to oblivion can have many stations. If the light consists of a broad energy band, selective action on the components of various energy levels results in changes of the spectral power distribution or in the spatial separation of components producing stimuli causing color sensations.

The ultimate fate of light is absorption; that is the photons of the light beam react with atoms or molecules that can respond to the energy level of the photons, and are absorbed by them, causing the outer electrons of the absorbing substance to be raised on the energy ladder. As they fall back to their normal state, the resulting energy is emitted as photons of a lower energy level in form of infrared radiation. The radiation is lost as a visual stimulus and is changed to a stimulus sensed as heat.

REFLECTING SURFACE

**2-4. Reflection of light
from a plane surface.**

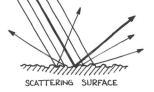

SCATTERING SURFACE

**2-5. The scattering of light
on an uneven surface.**

The most efficient absorber, by definition, is the black body, which absorbs and re-emits energy indiscriminately (but nonetheless by strict rules) over a wide energy band. Real objects are generally selective absorbers. Of particular interest is their absorption of light: they can absorb very little (such as a layer of "white" paint), they can absorb a lot (such as a layer of "black" paint), or they can absorb amounts in between. Since real objects do not absorb all the light energy falling on them, some of the photons have another fate: they are scattered or reflected. Scattering is a special form of reflection. Reflection is the process by which photons arriving at the surface of a material change their direction of travel on impact and are returned (like a ball, when thrown against a wall).[5] The laws of reflection indicate that if the reflecting surface is smooth, the angle of incidence (the angle at which the photons strike the surface) is equal to the angle of reflection (see Figure 2-4). Reflection is, therefore, unequivocally predictable, while scattering is only predictable in a statistical sense. It refers to reflection without a specific direction (multidirectional). It is caused by rough surfaces or fine particles. The surface involved may appear smooth to our senses, as does the surface of a layer of paint. The pigment particles in the paint, however, form a microscopically rough surface scattering light in many directions (see Figure 2-5). Representative scattering materials are textile fibers (fine-diameter, round, long columns of matter), water droplets (in the form of clouds and fog), smog and dust particles, and milk (fine oil droplets in an aqueous emulsion). Many colorants, in particular pigments, are scattering materials as well.

Scattering of photons also occurs in the atmosphere. Without it the sun's light would be very harsh in an otherwise dark sky, such as the astronauts have experienced on the moon. Daylight filling our sky is caused by the scattering of photons by water and dust particles in the atmosphere. Scattering by small particles is dependent on the relative sizes of particle and wavelength of light. Large particles or a large number of particles (such as in a fog) scatter all light equally and are perceived as being white. Heavily scattered sunlight, such as on a cloudy day or in a fog, seems to have no origin, as the photons meet our eyes literally from all sides and shadows are very soft or nonexistent. Few and small particles scatter short wave light rays more efficiently than long wave rays. While most light rays of longer wavelength pass through the atmosphere unscattered, a higher proportion of light of short wavelengths is scattered, resulting in a blue appearance of a clear sky. Clouds, which consist of a large number of water droplets, scatter light of all visible wavelengths equally and appear white. The chance of a

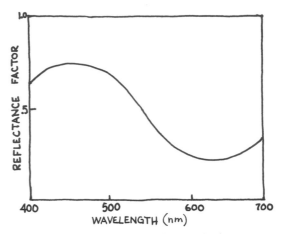

2-6. An example of the spectral reflectance factor of an object, causing a blue sensation when viewed under standard conditions.

photon being scattered also depends on the thickness of the atmospheric layer it has to penetrate. Thus, near sunset and especially in an atmosphere containing relatively high amounts of particles (such as in industrial areas), all except the longest wavelength direct sunlight is scattered, causing the disk of the sun to appear red. Blue color stimuli as a result of scattering are caused by the feathers of certain birds, such as the Kingfisher.

There exists no perfectly reflecting or scattering material. Some come quite close, for example the pressed surface of pure barium sulfate scatters approximately ninety-eight percent of the photons in the visible portion of the spectrum, regardless of wavelength, indiscriminately in all directions. Some of the best reflecting materials are plane metal surfaces such as mirrors. They reflect some seventy to eighty percent of photons arriving at the surface according to the laws of reflection.

Most color stimuli we encounter are created by wavelength-specific absorption and reflection. The material involved generally has properties causing it to absorb and reflect some photons of all energy levels, but those of some energy levels are absorbed or reflected to a much greater degree than others. The reflection characteristics of materials are expressed in form of reflectance factor curves (see Figure 2-6). They represent, at each wavelength, the ratio of the number of photons arriving at the surface (see Chapter 5 for further discussion).

Refraction

This term is used to denote a change in the direction of the path of photons when they pass from one medium into another. When light passing through

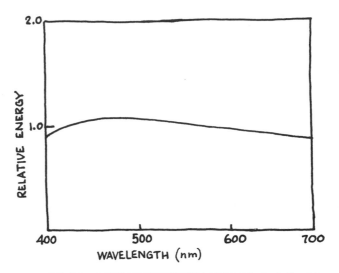

2-7. The spectral power distribution of the emission in the visible area of a black body at 6000°K.

air obliquely strikes the surface of a transparent object, such as water or glass, it changes its direction according to the laws of refraction.[6] This particular phenomenon is the basis of the formation of image in a camera or in the eye. In both of these cases the refraction is controlled by lens design. Photons striking the surface of a photographic lens or the lens of an eye at a given position (except for the center) change their direction as they pass through the lens and are in this manner focused on the film or on the retina to form an image, reduced in size, of the world in front of the lens. The change in direction is a function of the optical densities of the two transparent media involved (in the case of a photographic lens: lens material and air) and of the energy level of the photons (or of their wavelength). Photons of higher energy change more strongly in direction than those of lower energy. Refraction is, therefore, an efficient technique for separating the components of wavelengths in a mixture, such as that of sunlight. An effective tool is a glass prism; when a narrow beam of light composed of various wavelengths passes through a prism, the components are spread out as they leave the prism (see Plate A). The individual components, when seen under some standard conditions, are perceived to be colored. If the light used is, say, daylight, the colors perceived are those of the complete visible spectrum. Light from (always approximately) 400nm to 490nm causes a blue sensation, light from 490nm to 570nm a green sensation, from 570nm to 580nm a yellow sensation, from 580nm to 610nm an orange sensation, and from 610nm to 700nm a red sensation. When the direction of the flow of photons through the prism is reversed the resulting stimulus, when viewed under standard conditions, is seen as white (such as produced by a black-body radiator of about 6000°K, illustrated in Figure 2-7). We can conclude that when energy of all visible wavelengths is mixed in about equal amounts, the resulting stimulus causes a sensation of white.

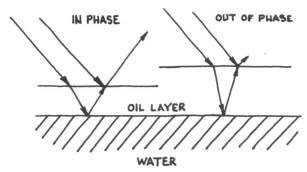

2-8. The schematic representation of interference due to a thin film of oil on the surface of water.

The most spectacular natural display of refraction is the rainbow. Refraction effects can also be observed in cut crystal, diamonds, or other gemstones having "fire." A difficulty caused by refraction is the chromatic aberration of lenses. Because of the specific effect of refraction on light of different wavelength, the photons of various wavelength in light emanating from a given point are not focused in the same point on the other side of a lens unless it is corrected for chromatic aberration.

Interference

Puddles of water with bright multicolored bands on the surface are a common occurrence near an auto-repair shop or a gas station after a rain shower. Similarly (and esthetically more appealing), bright shimmering colors can be seen on the wings of some butterflies when viewed from a certain angle, or on the feathers of some birds such as the peacock and the hummingbird. Such colors are called iridescent; hue and intensity of color change with the angle at which the surface is viewed. These color stimuli are due to a physical effect called interference, a term used to denote the temporary splitting of a lightwave into two parts, which are later recombined. Depending on the path the two beam components follow after splitting, the lightwaves may be in or out of phase when they are recombined; that is, the wave peaks and valleys may or may not match. If they do, the intensity of the resulting wave is the sum of that of its components; if they don't match, the two components cancel each other. A typical source of interference is a thin transparent film, such as an oil film on water (Figure 2-8). Whether or not the reflected light will be in or out of phase depends on the thickness of the film. If in phase, light of varying wavelengths will emerge at corresponding angles, giving rise to strong pure color stimuli, the color of which depends on the angle of viewing. Several colors (such as in water puddles with an oil film on the surface) can be seen from the same angle if the film causing the interference varies in thickness.

Diffraction

A special case of the combined effect of scattering and interference is diffraction. The behavior of a light wave arriving at the edge of a solid material (visualize the edge of a razor blade) is influenced by the sharpness of the edge. Depending on its wavelength in relation to the dimensional properties of the edge, the wave either passes unimpeded by the edge, is scattered at the edge, or is absorbed, reflected, or refracted by the edge-forming material. If several edges of proper dimensions exist, such as when fine lines are inscribed or etched into a glass or metal plate, the resultant scatter at the edges is subject to interference effects; waves in phase will reinforce each other and those out of phase cancel each other. When daylight strikes such an assembly of edges (called a grating), the waves in phase are enhanced in different directions; thus a display of the spectral colors results when the grating is viewed from many angles. A typical example is the surface of a long playing record, although because of the irregularity of the grooves and their curvature the effect is not strong nor well defined. Gratings made by ruling or other techniques are used extensively today for producing monochromatic light or light of a specific wavelength.

Certain organic substances such as the wings of some insects have structures with the dimensions necessary for diffraction effects. Another example is liquid crystal molecules. These are arranged in crystalline configuration such that they act as diffraction gratings. The dimension of the edges formed is a function of the surrounding temperature, and the substances can be used as temperature indicators. The colors of opals are also created by diffraction.

Molecular Orbitals

So far, we have concerned ourselves with physical sources of color stimuli (refraction, interference and so on) and with the behavior of excited electrons in atoms and molecules. In atoms as well as in molecules the electrons are arranged in orbitals[7] around the nucleus. When the outermost electrons of two atoms form a stable pair, the result is a chemical bond and the formation of a molecule. In some molecules the electrons are not confined to a particular orbital location but can move across larger areas of the molecule's surface. This behavior can give rise to color stimuli. A typical example of such behavior occurs in the "blue" gem sapphire, the basic material of which is aluminum oxide, a combination of aluminum and oxygen capable of forming crystalline structures. In its pure form this substance, called corundum, is hueless. Sapphire contains an amount of impurity in the form of iron and titanium atoms replacing the aluminum in some of the

2-9. The structural formula of the organic molecule benzene. *C* represent carbon atoms, *H* hydrogen atoms. The dashed line represents three electrons with unfixed position.

molecules. The aluminum in the molecule has three electric charges (represented by electrons), while iron has two and titanium four. One of the titanium electrons tends to transfer to a neighboring molecule containing iron. Both atoms end up with three electrons, the normal state for the aluminum in this compound. This charge transfer, an excited state, occurs only under the influence of absorbed energy. The energy needed is about two electron volts and can be supplied by absorbed photons of the visible range in a broad band from some 550nm to above 700nm. The energy released by the excited electrons is in the infrared band and is therefore not visible. When the sapphire is viewed illuminated by daylight, a deep blue color sensation results due to the reflection of light from 400nm to 550 nm.

A somewhat similar process takes place in most dyes and organic pigments. These are organic molecules based mainly on carbon, oxygen, and nitrogen. Carbon (as well as nitrogen under certain circumstances) can bond with itself, i.e. with other carbon atoms, and form chains with alternating single and double bonds. The best known example is the closed chain, or ring, of a benzene molecule, whose backbone consists of six carbon atoms with nine electron bonds between them (Figure 2-9). Depictions of the benzene molecule normally show alternating single and double bonds. However, the electrons involved in the double bonds are not located in a specific place but range over the total benzene molecule. Such bonds are said to be conjugated.[8] The energy necessary for the transfer of electrons from one place in the molecule to another is a minimum of 1.75 electron volts. In the case of benzene, which is colorless, the required energy is

above 3 electon volts in the ultraviolet region of the spectrum. More simply, benzene absorbs energy in the ultraviolet region. In other, more complex molecules the energy needed is that of the visible band and the substances appear colored due to absorption of light of specific wavelengths. Such systems of conjugated bonds are called chromophores.[9]

It is possible to attach to these molecules sidegroups capable of donating or accepting an electron. These groups are called auxochromes[10] and they affect the absorption characteristics of the chromophore involved. Two well-known natural substances derive their color from conjugated bond systems: blood and chlorophyll, the lifegiving substances of animals and plants respectively. Synthetic examples are represented by most organic colorants. It is likely that some one hundred thousand synthetic molecules with conjugated bond systems have been created in laboratories over the last one hundred twenty years in a never ending search for better colorants. Some eight thousand of these have had commercial significance in the past or have it today and are listed in the Colour Index.[11] For a more detailed discussion of colorants see Chapter 8.

Fluorescent colorants (also discussed under the heading Luminescence) represent a special case of conjugated bond systems. The energy absorbed by the electron transfer leads to the usual excited state. However, one of the steps in the energy ladder over which the electron passes on its way down to the normal state is such that the photon released has the necessary energy content to make it a color stimulus. Fluorescent colorant molecules are, therefore, both absorbers and emitters of visible energy.

Crystal-Field Colors

A dramatic display of a crystal-field color can be witnessed by visiting the Bryce Canyon National Park in Utah, with its huge, Gothic, weather-beaten columns of "reddish" sandstone. The reddish sensation is caused by iron oxide present in the sandstone. Other well-known examples of crystal-field colors are ruby and emerald. Ruby, like sapphire, is based on aluminum oxide, but some of the aluminum atoms are replaced with chromium. The crystalline structure of aluminum oxide creates an electric field, the crystal field. Chromium atoms present in this field result in absorption of the middle portion of the daylight spectrum, and a ruby, when viewed in daylight, creates a deep bluish-red color sensation due to reflection of the shortwave and longwave bands of light. The red color is due not only to absorption but also to fluorescence. One step on the excitation ladder results in the emission of longwave light contributing to the redness of a ruby. The color sensations resulting from viewing colorations made with many inorganic pigments (such as iron oxide) and those resulting from viewing of semiprecious stones, like turquoise, derive from crystal fields.

Electrical Conductors and Semiconductors

In the groups of materials known as the conductors and semiconductors, the outermost electrons are not restricted to the vicinity of the atom originally containing them but instead can travel freely over the whole volume of matter. Thus, in a copper wire, an electron can travel from one end of the wire to the other. The freely traveling electrons can occupy a very large number of rungs on the excitation ladder, that is, they can effectively absorb energy of many levels of energy content. One should expect that this would give metals a black appearance. But because of their unencumbered state, the emitted photons are visible and the electrons re-emit the absorbed energy and return to their ground state much more rapidly than those more firmly located. This behavior gives conductors their metallic appearance.

Semiconductors (the best known example of which is silicon) have four electrons per atom or molecule capable of undergoing chemical bonding. Semiconductors have a gap in their energy absorption behaviour: they can absorb energy only in bands separated from each other by a gap. Depending on the position of the gap in the energy ladder, the result can be absorption of visible energy and the appearance of color. One well-known colored semiconductor substance is cinnabar (mercury sulfide) a "red" mineral used as pigment. Another is cadmium sulfide, used as a "yellow" pigment. The colors caused by some semiconductors derive from the inclusion of impurities by a process called doping. Such semiconductors are used for example in *l*ight-emitting *d*iodes (LED displays of electronic gadgets). The particular value of semiconductors does not normally reside in their color-producing capabilities but in how they conduct electricity. They are important materials to the electronics field.

So far, several sources of color have been briefly described. But the list cannot be considered complete, and you are encouraged to explore further.[12] We have seen that in all cases (except the optical/geometrical ones) the outer electrons in atoms and molecules and their movements on the energy ladder are responsible for the creation of the photons that act as color stimuli. Our discussion has indicated the existence of considerable scientific understanding of the causes of color. But it should not be forgotten that this understanding is limited by the uncertainties and difficulties of the quantum theory. It is an understanding at an intermediate, not truly fundamental, level. It is thorough enough to make it possible today to create synthetic substances of very specific absorption or emission behaviour on demand. A most impressive example of this understanding is typified by the development of the laser,[13] a device used to create intense beams of light. The light is made up of photons all having the same wavelength with all the waves being phase, that is, in step with each other. Such light beams are termed coherent. Ordinary light, such as daylight, contains photons of many different wavelengths traveling partly in phase but mostly out of phase with each other. Lasers are based on principles discussed earlier in this chapter.

The first laser used ruby as a "lasing" material. In response to the emission of a flashtube, the outer electrons of the chromium impurity in the ruby are being raised to a highly excited state. The photons emitted by the electrons on returning to their normal state after absorbing energy from the flash result in an intense, coherent puse of light causing a red sensation. By proper manipulation it is possible to produce a continuous beam of light. Other lasing substances are dyes in which absorption is created by conjugated bonds, as we have seen. Today it is possible to create such beams with any wavelength of the visible spectrum and many outside. Lasers have many practical applications, such as in manufacturing and medicine as a cutting tool (by the precise focusing of an intense beam of energy resulting in heating, melting, evaporation, or combustion), in measuring of distances, and in holography. Their esthetic properties are occasionally also put to use.

Today there are few if any color phenomena the causes of which are not understood at the intermediate level of scientific understanding discussed earlier. The variety of sources of color and the complexity of their nature lead us to understand the difficulties persisting over many centuries in comprehending them (see Appendix).

Footnotes

1. *Incandescence* is from the Latin *incandescere*, meaning *to become hot*.

2. Electrons are fundamental particles with a negative electrical charge. An electron volt is the energy acquired by a particle of unit electronic charge when it falls through an electric potential difference of one volt.

3. See, for example, Glimm, J. and Jaffe, A., *Quantum Physics: A Functional Integral Point of View*, New York, New York: Springer, 1981.

4. Absolute temperature scale named after the British physicist W.T. Kelvin (1824-1907), abbreviated °K, based on the lowest possible temperature: $0°K = -273.15°C$. Its units are equal in size to those of the Celsius scale.

5. *Reflection* is from the Latin *reflectere*, meaning *to break*. In the Middle Ages it was known as cathoptrics and among the earliest investigated optical principles. For a complete discussion a standard textbook such as Sears et al, op.cit., should be consulted.

6. *Refraction* is from the Latin *refrangere*, meaning *to bend back*. In the Middle Ages, refraction was called dioptrics.

7. An orbital is a region of space related to an atom or molecule in which an electron is likely to be located.

8. *Conjugate* is from the Latin *conjugare*, meaning *to yoke together*. An organic substance containing conjugated bonds has two or more double bonds separated by single bonds.

9. *Chromophore* means color carrier, from the Greek *chroma*, meaning *color*, and *phorein*, meaning *to bear*.

10. *Auxochrome* means color enhancer, from the Greek *auxein*, meaning *to grow*, and *chroma*, meaning *color*.

11. *Colour Index*, Society of Dyers and Colorists and American Association of Textile Chemists and Colorists, third edition (second revision), 1982.

12. For a detailed discussion of the subject matter of much of this chapter see Nassau, K., "The Causes of Color," *Scientific American* 243 (1980), No.4 (October), pp. 124-154.

13. Laser is an acronym for *l*ight *a*mplification by *s*timulated *e*mission of *r*adiation.

3

From the Stimulus to the Response

Before proceeding with a description of the major phenomena of color sensation it is necessary to describe, in more detail than that given in Chapter 1, the apparatus of human color vision. Figure 3-1 is a schematic cross section of the human eye. The eye is held in place and is moved by six muscles. The cornea[1] forms the outer surface of the eye and acts as a protective shield for the more delicate inner components. The lens is formed of elastic tissue. By a process of refraction, it focuses the image of what the person is looking at, in form of streams of photons, on the retina. The central portion of the image is focused on the most sensitive area of the retina, the fovea. Controlled change of the shape of the lens by automatic muscle action allows sharp focusing on objects nearby or very distant. The transparent substances filling the lens and the body of the eye itself (the latter is called vitreous humor) are not equally transparent to light of all wavelengths and in fact absorb a considerable amount of short wavelength light. The degree of absorption generally increases with age. The number of photons passing through the lens is controlled by the iris, which forms a circular opening. The size of the opening is varied by expansion and contraction. The ratio of light passing through the opening at its smallest and largest size is about 1:15.

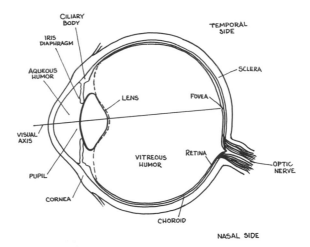

3-1. Horizontal cross section of human eye.

The retina contains some one hundred twenty million photosensitive cells, the rods and the cones, whose distribution varies widely throughout the retina. The cones, responsible for color vision, are only some seven million in number and are located mainly in the fovea. The rods, on the other hand, are absent in the fovea but present in the outer area of the retina. The number of rods increases at first away from the fovea and then decreases toward the edge of the retina and the periphery of vision. Rods and cones are connected to other cells in a very complex pattern (Figure 3-2). The information created in the rods and cones by photons absorbed by them passes through the connecting cells and is funneled out of the eye by the optic nerve. The optic nerve exit from the retina forms a circular blind spot in our field of vision. Normally we are not aware of it, but it can be made visible.

From the eye the optic nerve fibers proceed into the brain. They are separated in the optic chiasm and proceed into the two halves of the brain (Figure 3-3). The information from the left half of the visual field from both eyes, is funneled into the right half of the brain and vice versa. The reason for this separation is not clear. To have information from both eyes in each half of the brain can serve the purpose of redundancy, and is useful in the case of damage to eye or brain. The advantage of a visual field separated into two halves along an invisible vertical line remains unexplained for now, however.

A major further waystation along the information path is the lateral geniculate nucleus.[2] From here, the information proceeds to the visual centers of the brain at the back of the head. At this point the traceable flow of signals ends. The conversion to a sensation and the shaping of perceptions remain mysteries.

The chemical substance in the rods responsible for vision signals based on the absorption of light quanta is well known. It is called rhodopsin, or visual purple. When absorbing light quanta, rhodopsin undergoes a

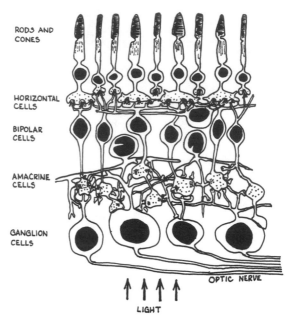

RODS AND
CONES

HORIZONTAL
CELLS

BIPOLAR
CELLS

AMACRINE
CELLS

GANGLION
CELLS

OPTIC NERVE

LIGHT

3-2. Schematic representation of the rods and cones involved in vision, and the subsequent cell structure in the retina.

molecular change triggering a response in the rod cell. The likelihood of a photon being absorbed by rhodopsin depends on its energy level. Its greatest chance for being absorbed exists if it has an energy corresponding to a wavelength of 500nm to 510nm. If it has a higher or lower energy level, the chances for absorption are reduced. The curve in Figure 3-4 illustrates the absorption characteristics of rhodopsin. The facts behind this curve can be compared metaphorically to those of a dart game. Only if the dart

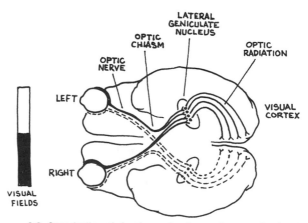

LATERAL
GENICULATE
NUCLEUS

OPTIC
CHIASM

OPTIC
NERVE

OPTIC
RADIATION

LEFT

VISUAL
CORTEX

RIGHT

VISUAL
FIELDS

3-3. Organization of visual neural pathways from eye to visual cortex.

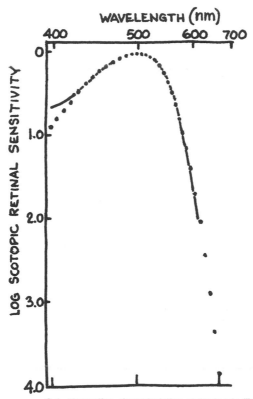

3-4. Absorption characteristics of rhodopsin (line) and relative sensitivity of the dark-adapted human eye (circles).

released by the hand has the right speed (energy level) and, of course, direction will it strike the center of the target. If the energy level is lower or higher the center of the target will be under- or overshot, with results reduced in terms of points. Similarly, at energy levels above or beyond 500nm to 510nm the chances of absorption of the photon are reduced with corresponding reduction in the effectiveness of the photon in producing a chemical change in rhodopsin. The figure contains, superimposed, the results of psychological tests. The persons taking the test have been dark-adapted, that is, before beginning the test they have sat for an hour or so in the dark. The test consists of determining at various wavelengths the relative number of photons necessary for an observer to detect a light flash in an otherwise dark field of vision. The result of the experiment matches closely the measured absorption curve of rhodopsin except for the short-wavelength area[3] and reveals the dependence of a fundamental visual response on the characteristics of the photosensitive absorbing substance.

The determination of the absorption characteristics of the active chemicals has also been attempted with cones. This is much more difficult, however, since the number of cones is much smaller than that of rods and the three types are intermingled in the fovea. Taking various sets of exper-

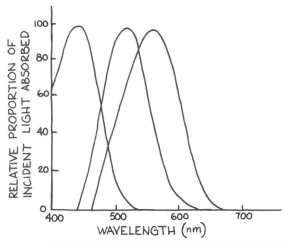

3-5. Absorption characteristics of three types of cones in the human retina, with peak height arbitrarily adjusted to 100.

imental data into account, the best current estimate of the absorption characteristics of the chemical substances involved (sometimes named cyanolabe, chlorolabe and erythrolabe[4]) is illustrated in Figure 3-5. Because of their overlapping absorption bands, a simple correlation with psychological data of color vision (such as shown in Figure 3-4) is not possible. But curves as in Figure 3-5 can be reconstructed in a relatively straightforward mathematical way from psychological test results of color vision (see Chapter 6). The three cone types are believed to be present in the foveal region of the retina in a ratio of $32:16:1$.[5] If this information is incorporated into the basic absorption characteristics, a set of curves results (Figure 3-6), from which it is possible to read the relative chances of a photon with a particular energy content to be absorbed by a given cone. Thus, it can be determined from Figure 3-6 that a photon with the energy corresponding to a wavelength of, say, 480nm is about ten times more likely to be absorbed by a D-cone than by a T-cone and about eight times more likely than by a P-cone.[6]

It becomes apparent that for both rods and cones the physical characteristics of the light-sensitive substances they contain can be correlated fairly closely with certain basic perceptual responses (under controlled conditions) to light stimuli. On the other hand, much additional behaviour of the color vision system, as disclosed by psychological tests, is not explained simply on the basis of receptor absorption characteristics.

The light-sensitive substances in rods and cones undergo a chemical change under the influence of absorbed photons. These changes, in turn, trigger minute bursts of electrical current caused by electrochemical activity. However, such bursts, or spikes, also occur spontaneously in the cells at certain intervals. Upon absorption of photons the rate of bursts increases dramatically. These bursts in turn trigger electrochemical activity in adjoining cells. Depending on the nature of these cells their spike rates may increase, or sometimes decrease to below the normal rate. In this manner various electrical signals are created; these are subject to measurement with

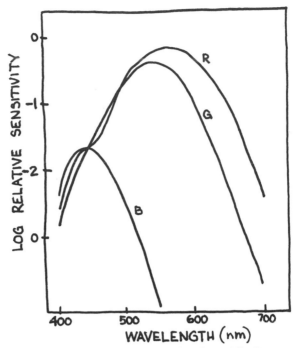

3-6. Total spectral response functions of the three cone cell types adjusted for their relative number present in the retina.

sophisticated equipment and can be followed (in primate animals) along the visual pathway.[7] In the horizontal, bipolar, amacrine and ganglion cells that follow the rods and cones (Figure 3-2), the original signals are modified as outlined. However, the exact functions of these cells are not fully understood. The results, in the ganglion cells and even more so later on in the lateral geniculate nucleus (LGN), show a behavior of the system on exposure to light of various wavelengths that is different from the original three-receptor response. Six cell types with wavelength-specific behavior but different response have been identified in the LGN of primate animals (Figure 3-7). It is likely that similar responses exist in the human LGN. The signals created in the cones and represented by Figure 3-6 have been modified by the intervening mechanisms to result in the signals represented by Figure 3-7. It illustrates the number of spikes produced in the six different types of LGN cells when exposed to stimuli from 400nm to 700 nm. The dashed lines indicate the spike rate of the cell at rest, that is, not stimulated. The cell types in the right-hand column appear to have a response that is approximately the mirror image of that of their counterpart cells in the left-hand column. While the signals of the top four cell types are chromatic (that is, they signal hue and saturation) those of the two types on the bottom signal brightness.

Also in this case approximate psychological correlates have been found. They form the basis of the so-called opponent-color theory.[8] According to this theory there are three opposing pairs of fundamental color sen-

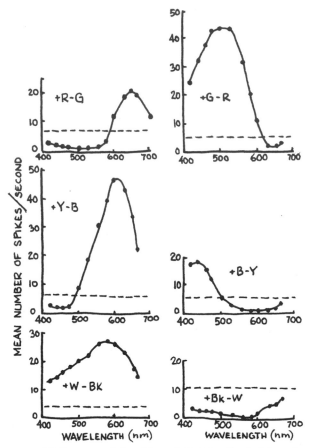

3-7. Response of six cell types in the lateral geniculate nucleus (LGN) to spectral light as represented by the average spike rates of the cells.

sations—red-green, yellow-blue, and black-white—and all color sensations are composed of these fundamental ones. Perceptual opponent-color responses have been isolated using hue-cancellation experiments. These experiments are based on the finding that stimuli causing opposing hue sensations (for example, those resulting in red and green sensations), when mixed together in correct proportion, produce a new sensation seen as hueless, or achromatic: white or gray. An example of a cancellation experiment involves mixing light producing a sensation containing a fundamental yellow component (from approximately 500nm to 700nm) at given wavelength intervals with light of a wavelength of approximately 475nm producing the fundamental blue sensation (neither greenish blue nor reddish blue). The amount of the blue-appearing light necessary to cancel the yellowness perceived in each of the test stimuli (that is, until no more yellowness is perceived) is recorded and assumed to be a measure of the yellow response.

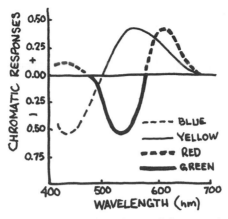

3-8. Results of cancellation experiments illustrating the response of the yellow, red, blue, and green mechanisms.

Similar experiments were run to isolate the blue, green, and red responses; the results are shown in Figure 3-8. As mentioned earlier, the opponent-color theory postulates that all color sensations are composites of these fundamental sensations. The curves indicate that for, say, light of 550nm the green response is, on a relative scale, −0.5 and the yellow response is 0.4. Together, these two responses create the yellowish green sensation obtained from light at this wavelength under normal conditions. The relationship of these psychological response curves to some of the physiological response curves (measured in the LGN) of Figure 3-7 is clearly apparent. This relationship appears to lend support to the contention that further along the visual neural pathway the visual system is organized according to opponent-color principles. Color scientists speak of a two-stage processing system, the first stage consisting of the absorption by the three cone types and the second stage of the conversion to opponent-color signals. The question remains as to how exactly the three original receptor signals are converted to opponent-color signals.[9] One theory that can muster considerable support both from physiological as well as perceptual data is illustrated schematically in Figure 3-9. Output from the P-cone is subtracted

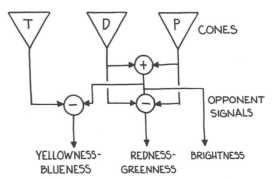

3-9. Hypothetical linkage of the cone cells to produce opponent-color response.

from that of the D-cone to form the red-green opponent signal. The signals from these cones, in other, following cells, are also added to form the whiteness signal. The whiteness signal, in other cells again, is subtracted from the T-cone response to form the yellow-blue opponent signal. Theoretical opponent-color signal curves closely resembling the perceptual ones in Figure 3-8 can be mathematically constructed from these relationships and the cone responses of Figure 3-6. They are illustrated in Figure 3-10.

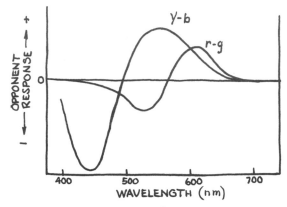

3-10. Theoretical opponent-color response functions based on cone cell responses and assumed linkages to produce opponent-color response.

The fate of the visual signals past the LGN is not well understood and is currently the subject of research. It is known that the signals proceed to the primary visual cortex (located in the lower back portion of the head). There are indications that the signals may not completely cease at this point but in changed form proceed to other areas of the brain. The step from the arrival of the signal at the visual cortex to the conscious sensation of color remains a mystery.

We come to the conclusion that considerable knowledge exists about the physiological mechanisms of color vision (of which this chapter is but a brief summary). Much remains to be learned. The existing knowledge should not make us forget that the sum is more than its parts. Color is more than a physiological mechanism and, like any other of the components of our consciousness, is ultimately unexplainable.

Footnotes

1. *Cornea* is from the Latin *corneus,* meaning *hornlike.*

2. This is an anatomical term: *Nucleus,* Latin, meaning *kernel; geniculate,* from Latin *geniculatus,* meaning *knotted; lateral,* from the Latin *lateralis,* meaning *of the side.* The lateral geniculate nucleus is masses of gray matter intricately organized, on both sides of the brain.

3. The results of the perceptual experiments have been adjusted for the transmission characteristics of the eye media.

4. These words are based, respectively, on the Greek *kyanos,* meaning *blue; chloros,* meaning *green; erythros,* meaning *red.*

5. The relationship of 32:16:1 is based on physiological as well as psychological data. The cones in the fovea are believed to form a more or less regular mosaic with the three cone types present in the ratio indicated.

6. The designative letters P,D, and T derive from the terms protanopic, deuteranopic, and tritanopic. They are based respectively on the Greek words *protos,* meaning *first of a series; deutos,* meaning *second; tritos* meaning *third.*

7. Descriptions of these measurements and their results are found in Hurvich, L.M., *Color Vision,* Sunderland, Massachusetts: Sinauer Associates, 1981.

8. The originator of the opponent-color theory was the German physiologist Ewald Hering (1834–1918). See Hering, E., *Outlines of a Theory of the Light Sense,* translation by L.M. Hurvich and D. Jameson, Cambridge, Massachusetts: Harvard University Press, 1964, as well as Appendix I of this book. An up-to-date exposition of color vision from the viewpoint of opponent-color theory is given by Hurvich, op. cit.

9. There are several proposals in the literature differing only in relatively minor respects. Incontrovertible facts that would lead to the acceptance of one version and rejection of the others have not yet been found.

4

Color Perception Phenomena

Unrelated Colors

Color can be experienced either as isolated, unrelated phenomenon, say a red sensation caused by light from a lamp seen at night at some distance or, more commonly, as a phenomenon seen in relation to other such phenomena, say, the sensation caused by viewing an orange in a fruit basket illuminated by the sun.

Unrelated colors are normally seen as caused by light—light from lamps, traffic lights, flames, and neon advertisements—while related colors are generally seen as belonging to materials. A distinguishing feature of unrelated colors is their brightness. Brightness is an attribute of a visual sensation according to which an area seems to exhibit more or less light.[1] The light from a sixty-watt electric bulb is brighter than that from a candle.

Another feature of colors (both related and unrelated) is hue, a qualitative aspect of colors quite difficult to define. It is what we mean when we

say something is yellow, red, blue, green, and so forth. There are hueless colors, called achromatic, comprising white, black, and grays. All other colors, called chromatic, have a hue. How many hues are there and what, if any, is their relationship? To attempt to answer this question we may want to recall from memory the picture of a rainbow or look at the visible spectrum, the band of colors created when passing a narrow beam of sunlight through a glass prism in a dark room (see Plate A). Not only is there a whole series of hues for which we can think of names but we can even think of hues that are not present in the spectrum, such as certain shades of purple and violet. A little reflection will show the number of singular hues that can only be described in terms of themselves and not in terms of other hues to be quite limited. Take orange as an example. It is clearly related to both yellow and red. In fact, it is difficult to decide where yellow ends and orange begins. Similarly, there is no clear borderline between orange and red. There is no orange hue in which we cannot see both yellow and red. But there are certainly red hues in which there is no orange or yellow. Yellow and red are two fundamental hues termed unique or unitary.[2] Two others are blue and green. Blue is easily recognized as another unique hue while we may have some difficulties doing the same with green. These difficulties can be attributed to our knowledge that, technologically, green colors are often produced from an admixture of "yellow" and "blue" colorants while the other three unique hues cannot be created by similar admixtures. The unique hues are specifically those in which other unique hues cannot be recognized: unique blue is that blue which is neither reddish nor greenish, unique green is a green that is neither yellowish nor bluish, and so forth. All other hues can be seen as a mixture of unique hues, thus turquoise blue can be seen as an equal mixture of unique blue and unique green. Violet can be seen as a mixture of unique red and unique blue. We come to the conclusion that there are many hues but only four, the unique hues, that can only be classified in terms of themselves.

A third attribute of unrelated colors is chromaticness and its relative, saturation.[3] Chromaticness is the attribute of visual sensation according to which an area appears to exhibit more or less chromatic color. Chromaticness is best visualized by considering a red sensation caused by the light of a lamp connected to a battery via a controller allowing us to increase or decrease the amount of electrical energy flowing to the lamp and in this manner to increase and decrease the flow of photons from the lamp. The lamp is located in a dark room. As we begin, from zero, to increase the amount of electricity flowing to the lamp the light becomes brighter and brighter and, in terms of the red color sensation it produces, more and more colorful, that is, having higher and higher chromaticness.

Let us introduce a second light causing a sensation of white. At medium brightness of the "red" light, one that is not uncomfortable to view, we adjust the brightness of the "white" light until both brightnesses are judged to be equal. We now have a chromatic and an achromatic color sensation of equal brightness. We can imagine an optical gadget (not very difficult to construct) allowing us to mix portions of the two lights in various ratios and we can create a series of colors of equal brightness but varying

content of chromatic color. These colors are said to differ in saturation. Saturation, then, is an attribute of a visual sensation according to which an area exhibits more or less chromatic color in proportion to its brightness. Chromaticness is an absolute measure of chromatic content of a color regardless of its brightness, while saturation is a measure of the chromatic content of colors of equal brightness.

Related Colors

We have said that related colors are those generally caused by objects in the presence of other objects. It is possible, however, for the color sensation caused by an object to be seen as related or unrelated, depending on circumstances. If the quantity of light coming from the surround is much lower than that of the field causing the color sensation, the color is seen as unrelated. In cases where the quantities are comparable, the two colors (that caused by the object and that caused by the surround) are related. The transition between the related and the unrelated state is continuous. This can be demonstrated, for example, in a town at dusk. Advertising lamps and neon signs, if turned on during daylight, appear as colored objects, indistinguishable from many others that are not internally lighted. As the light level of the surround declines with dusk proceeding, the sensations caused by these lamps are progressively brighter and more saturated. At one point they begin to appear glowing or fluorescent as their brightness is somewhat higher than that of the sensations caused by other nearby, not internally lighted objects.[4] As dusk becomes darkness, the other objects become less and less visible, the lamps and neon signs assume the appearance of light sources and the color sensations caused by them are now unrelated. A simple technique to see related colors as unrelated is to cut a small hole (two to three millimeters in diameter) into a sheet of black construction paper. Such a device is called a reduction screen. By holding the opening close to one eye, color sensations caused by objects are seen as unrelated since the surround is always darker and the objects cannot be recognized.

Lightness

The majority of our color experiences involves related colors, our everyday world of colored objects and materials as seen illuminated by some natural

or artificial light source. In some instances we remain conscious of the brightness of colors, such as in looking upon a dazzling area of a snow-covered field on which sunlight falls compared to looking at a neighboring area in the shade (it appears to be an unrelated color). But we may also be interested in the relative amount of light being reflected from one surface as compared to another; this is a difference in lightness, an attribute of visual sensation according to which an area appears to reflect a greater or smaller portion of light falling on it. Its opposite is darkness; the surface of a lump of coal clearly reflects less light than that of a white eggshell. The eggshell's lightness is, therefore, lower or its darkness higher. It is lightness that is a significant aspect of the mental picture of our surroundings based on our sensations. It is not difficult to create two situations in which the absolute amount of light reflected from a lump of charcoal in one case is higher than that reflected from an eggshell in the other case. The charcoal, because of its much lower lightness, will nevertheless appear to be darker than the egg. Another way to look at lightness is that it is the judgment of the brightness of a related color in relation to the average brightness of the surrounding colors.

Hue and Chroma, Grayness

The phenomenon of hue is comparable for unrelated and related colors. Our discussion above applies here as well. And so it does for chromatic-ness. A small problem is encountered concerning saturation, however. By definition, it is the chromatic content of a color judged relative to its bright-ness. It is desirable to have a comparable term for related colors relative to their lightness. The term used for this purpose is *chroma*. It is the attribute of a visual sensation according to which a related color exhibits more or less chromatic color judged in proportion to the lightness or the average bright-ness of surround.

A related achromatic (or hueless) color with maximum lightness (no darkness) is called white. Its opposite, a color with maximum darkness (no lightness) is called black. Achromatic colors perceived as having both light-ness and darkness are called gray. A particular visual phenomenon is our ability to perceive grayness in certain chromatic colors. Thus, brown can be defined as an orange color with considerable gray content. Any related color can be described in terms of hue, chromatic content, and white and black (or gray) content.[5] A particular group of colors is those with zero gray content.[4] Recalling our experiment of observing a shopping area of a town at dusk, there is a level of illumination (or a moment in time) at which, say, the color caused by an illuminated advertising sign appears neither to con-tain any grayness nor to be fluorescent or luminous. In this condition the color caused by the sign has zero gray content. If at that moment the light

output of the lamp in the sign were reduced, the resulting color sensation would have a gray content again and appear to be related; if it were increased, the color would look luminous and appear to be unrelated.

Metallic Colors

Another group of colors we perceive as unique are the metallic colors. The metal gold produces a yellow color sensation that is normally seen as related. However the yellow sensation caused by gold is easily distinguishable from another yellow of the same hue, lightness, and chroma. We are touching here on an aspect of the appearance of objects not strictly related to color. It involves a certain glossiness of the surface, which we have learned to recognize as metallic. Thus, silver causes a metallic gray and copper a metallic reddish brown color sensation. For a brief discussion of the physical basis of metallic appearance, see Chapter 2.

Adaptation

The human visual system has the remarkable ability to adapt itself to the prevailing average quality and quantity of light. This process of modification of certain properties of the visual system is called adaptation. The result of adaptation is that despite considerable changes in intensity and quality of the illuminating light the effect on the perceived colors of objects is small. If our visual system is properly adapted, the color sensations caused by the contents of our fruit bowl will be perceived as being essentially the same in the bright sunlight of a clear day, in the diffuse light of an overcast sky, or in the yellowish light of a lightbulb in the evening. Similarly, a piece of white paper does not appear to be as bright in the bright daylight to which we have grown accustomed as it does in office lighting, even though in the former case the absolute amount of light reflected from the paper and entering our eyes is substantially higher (maybe by a factor of 1000).

Adaptation to the level, or quantity of light is somewhat easier to understand than qualitative adaptation, and the (inexact) metaphor of the camera can be used to illustrate it. In the case of the camera, the f-stop of the aperture is used together with the shutter speed to control the amount of light arriving at the surface of the film. In the case of the eye, the f-stop adjustment is duplicated by the expansion or contraction of the iris. The resemblance ends there, however. Further significant sensitivity adjustment

in vision is accomplished by other means. Adaptation to the quality of light seems even more remarkable and delicate. While there are many ways to demonstrate it, the following simple methods can be used. After spending some time in a normal lighted environment, cover one eye with an opaque patch and, keeping the other eye open, spend three or four minutes in a darkroom illuminated only with a standard "red" darkroom lamp. Return to the normal lighted environment and observe that everything has assumed a perceived greenish coloration. Close the eye, remove the patch from the other eye and observe that, seen with this eye, all objects have their normal perceived coloration. Observe further that after a few minutes the eye partially adapted to the "red" light (it takes considerably longer than three or four minutes for a complete adaptation) has "returned to normal." Adaptation has shifted the hues of all objects illuminated by the "red" light away from reddishness towards a more neutral, normal coloration, in other words, towards greenishness. More correctly expressed, the receptor response characteristics have been changed under the influence of the long-wavelength light illumination resulting in a response as it occurs under more neutral illumination. This change in characteristics can be made visible by a sudden change to neutral illumination in which the objects are temporarily perceived as having a hue opposite in character to that of the light source. For a second experiment a so-called plant growing fluorescent lamp, such as a Westinghouse Agro-Lite perceived by the neutrally adapted eye to radiate light causing a distinctly pinkish color sensation) is required. From a room with standard daylight illumination in which you have been for a while, step into a room illuminated with the plant-growing lamp. Observe the pinkish appearance of the light on objects. Remain in the room for several minutes to observe the fading of the perceived pinkish color of objects: "white" paper will assume its normal white color, a lemon will be sensed as yellow again, rather than orange, and so forth. After some fifteen minutes, step into the daylight illuminated environment again and observe the greenish sensation caused by objects. Notice the slow change back to a "normal" color.

These examples illustrate quite drastic cases of adaptation. Adaptation is a continuous and ever-present process that normally goes unnoticed, however. Carefully designed experiments have shown some aspects of the adaptation process to occur very rapidly. Sometimes the term "masking" is used in this case. Other aspects, as we have seen in our experiments, take a considerable amount of time. The longest time span is required for dark adaptation, the situation allowing us to see stars at night or even a single candle at a distance of a mile or more. It takes an hour or longer to obtain complete dark adaptation.

The purpose of adaptation is not difficult to guess. It is of obvious use to a creature to be able to distinguish between enemy and friend in the brightest sunlight as well as in the dark. It is also important to distinguish edible from poisonous plants and fruits regardless of the time of day and the spectral power distribution of daylight. This distribution changes relatively slowly during the day and continuous adaptation insures essential color stability of the perceived image. It is likely that intensity adaptation as well as

chromatic adaptation have developed by evolutionary process to aid in the survival of animals and humans.

Color Constancy

An important aspect of adaptation is color constancy. We encountered it earlier when we realized that despite a yellowish sensation caused by incandescent light in a room, after proper adaptation "white" paper will again produce a white sensation and "pink" flowers look pink. Objects are color-constant if their apparent color does not change (after allowing for adaptation) regardless of the quality of light in which they are viewed. According to this very general definition there is probably no color-constant object in existence. If we should use, say, a narrow band of the portion of the spectrum causing a blue sensation as our light source, we would not adapt completely and the apparent color of objects would never be the same as in daylight. We need to restrict the definition to light causing a white or only lightly hued sensation. A situation of considerable practical importance for artists, designers, dyers, graphic printers, and the like is exemplified by daylight and incandescent light, the light of the common lightbulb. While most objects containing natural colorants will produce approximately the same color sensation when viewed in either light, the perceived color can change considerably for objects containing certain artificial colorants. The implications are clear: if the painting when hanging on the museum wall bathed in the light of a flood lamp is to look as the painter intended, the paints used in daylight need to be chosen carefully or the painting should be done in incandescent light. Similarly, a shirt and matching tie selected in the store light should, to avoid unesthetic surprises, be examined, as they frequently are, in natural daylight.

An example of a coloration relatively color constant for the change from daylight to incandescent light and one rather color inconstant are illustrated on the jacket of the book. The coloration on the left side (after covering the one on the right side) will produce essentially the same color sensation when viewed in daylight or incandescent light, while the one on the right (after covering the one on the left side) will show a considerable change in perceived color from daylight to tungsten light. Light from fluorescent lamps, especially some of the newer energy-efficient ones, can occasionally reveal remarkable color-inconstancy of certain objects.

The question of color constancy considers the problem from the point of view of the objects. Conversely, we can also look at it from the point of view of the light source.[6] We then speak of the color-rendering properties of light sources. Light sources with blackbody spectral power distributions are considered to be the standard and other light sources may render the perceived color of objects more or less different and, therefore, have better or poorer color rendering properties.

Metamerism

One of the more surprising visual phenomena is related to color constancy but involves at least two objects. It is, however, not restricted to related colors but applies to all color stimuli. For related colors it is exemplified by the two samples on the book's jacket. If we view the plate in the natural light of the northern sky most of us will agree that the color sensations arising from viewing the left and the right side are very similar or possibly identical. If we look at the plate illuminated by incandescent light we find that the two sides are substantially different in perceived color. We remember from our earlier viewing of the plate that the left side is quite color-constant in daylight and tungsten light, while the right side is not. It is apparent that the spectral power distribution of the photons arriving at the eye from both colorations cause identical or near identical sensations in the case of daylight illumination, while in the case of the incandescent illumination they do not. Such matches are called conditional or metameric. (By definition the sensations must be identical, or matching, for the spectral power distributions that cause them to be called metameric).

How is it possible for two objects to cause identical sensations when viewed in one light but different sensations when viewed in another? We can further clarify the phenomenon with another experiment. If we project a beam of light through a narrow slit and a glass prism onto a white surface in a dark room we will find a display of the visible spectrum of light (as illustrated in Plate A). Only a narrow band of that spectrum produces a yellow sensation attributed to a lemon. If we can take a lemon (or similarly colored paper), place it in front of the slit and shine light on it so that some of it is reflected through the slit and the prism, we will find on the screen not just the narrow band of light which we have identified earlier as causing a similar color sensation as a lemon, but actually a broad band producing from bluish green to red sensations (since the amount of light passing through the prism is much smaller, the display is much weaker than that produced by the light source itself). A yellow sensation similar to that caused by a lemon can also be produced by inserting sodium salts, such as common salt, into a hot flame. By placing a few common salt crystals on the point of a (disposable) steel knife blade and heating them with the flame of a gas cigarette lighter (adjusting it to have a "blue" flame), a strongly yellow sensation is produced (see also Chapter 2). If we pass the light emitted by the heated salt through our slit/prism arrangement in otherwise dark surroundings, we will find on the screen predominantly one narrow band producing a yellow sensation[7] (there will also be some other bands as we most likely have not excluded all the light from the gas flame itself). Our simple experiments show us that a comparable yellow sensation can be produced by light consisting of one or two narrow bands only or of light consisting of a broad band of components with different wavelengths. In other words, qualitatively vastly different lights can produce the same color sensation. Metameric spectral power distributions are those inducing the same sensation but being qualitatively different

stimuli. On the back jacket of the book are two reflecting surfaces resulting, when viewed in the proper light, in metameric spectral power distributions causing identical sensations (or nearly so). That the two surfaces are qualitatively different can be deduced from the fact that when the two objects are viewed in another light (incandescent, for example) the resulting sensations do not match anymore. The question of how the two sides can be qualitatively different yet produce matching sensations we will leave for a later discussion. Metamerism is a very fundamental aspect of color vision. It leads to many technical difficulties but it is also the basis for the relatively simple color reproduction techniques in use today in printing, photography, and television (see Chapter 9).

Simultaneous and Successive Contrast, Afterimages

Experiments with a reduction screen, as described earlier in this chapter, can give us considerable insight into how neighboring areas causing different color sensations can affect the specific sensation caused by a given area. Such effects are known as contrast effects. Contrast is the subjective assessment of two parts of a field of view seen simultanously or successively. Examples of simultaneous contrast are seen on Plate B. Surprisingly, the printing ink used for the central figure is identical in all four cases, which becomes evident when masking the surrounding areas. The examples illustrate not only the effect of contrast on perceived brightness and hue but in particular also the effect on the perceived difference between two color stimuli. Such effects are particularly important for artists and decorators. Often, colored objects having been selected individually in the belief that they are harmonious are discovered to clash when seen adjoining.

A well-known example of simultaneous contrast is colored shadows.[8] To demonstrate it two flashlights can be used, one with a "green" cellophane sheet over the bulb, the other without. If they are placed at an angle of some ninety degrees such that they both illuminate a highly reflecting screen or wall in an otherwise dark room, the screen is perceived as having a fairly uniform greenish color. If an object is placed so as to throw shadows on the screen (as in Figure 4-1), one shadow is seen as distinctly greenish: it is the one in which the light perceived as white is obstructed and the shadow is filled by the light of the "green" lamp. However, the other shadow where the light causing the green sensation is obstructed is not perceived as gray as one might expect, but has a distinctly reddish hue due to the simultaneous contrast effect.

An example of the inducement of successive contrast is given with the help of Plate C. After staring intently for a minute or so at the dot in the left portion of the figure, fix your gaze at the dot on the right side. A distinct

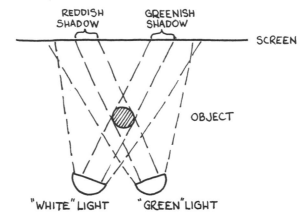

4-1. Schematic view of an arrangement designed to produce colored shadows.

image of the left figure will appear but colored in what is often referred to as the complementary color, that is, a color perceptually opposite to the original color.[9] This effect is called a negative afterimage. Under certain conditions it is also possible to observe a positive afterimage in which the perceived color of the observed object remains the same. Afterimages can be seen with open eyes but usually equally well with closed eyes. It is easy to experience this using Plate C.

Perceived Nonuniformity due to Surround

Another effect to be discussed is that illustrated in Figure 4-2. The perceived achromatic color of each of the steps is seen as varying significantly across each step. By masking adjoining steps it is easily seen that the steps are, in fact, uniform in perceived color.

4-2. Gray color series, with gradations illustrating perceived nonuniformity due to surround.

This effect and the contrast effects discussed earlier reveal certain properties of the visual system. They disclose information about its operation. To reiterate, the primary purpose of these effects seems to be to aid in the survival of the species. It is likely that they evolved at a time when, much more than today, survival depended on the ability to clearly distinguish between elements in a scene. Thus, minor differences in lightness, hue, or chroma of adjoining areas in a scene are intensified by contrast effect to make them more easily perceived, resulting in our improved judgments of their nature. Such differences can be caused by an enemy in hiding or by sources of food otherwise unnoticed.

We have seen that our experience of color is subject to a considerable number of phenomena. They form, in a sense, the alphabet of color vision. We experience one or more of them (only the more important have been described in his chapter) just about all the time but we have generally grown accustomed to them to a degree that we often do not notice them. However, anyone involved creatively or technically with color or its reproduction needs to be aware of them. Involvement with these phenomena provides a better understanding of the complexities of color perception, in particular the awareness that color sensations cannot be controlled via just the light-reflecting or -transmitting characteristics of the objects involved, but require control of surroundings and illumination as well.

Footnotes

1. Most of the definitions given in this chapter are those (if often not verbatim) of the International Lighting Vocabulary of the Commission Internationale de l'Eclairage (CIE, International Commission on Illumination), Publication CIE Nr. 17, currently under revision.

2. The idea of unique or unitary hues is credited to the German physiologist Ewald Hering (1834-1918) who proposed it in 1905. See Hering, E., op. cit.

3. *Chromaticness* is used in this text in the sense proposed by Wyszecki: (see Bibliography). Instead of the term *chromaticness,* Hunt has proposed the term *colorfulness.* For a detailed description of colorfulness, saturation, chroma, and their relationships, see Hunt, R.W.G, op.cit.

4. An extensive discussion of these and many other matters of color perception is found in Evans, R.M., *The Perception of Color,* New York, New York: John Wiley & Sons, 1974.

5. A modern system of color specification based on this principle is the Natural Colour System of the Swedish Colour Centre (see Chapter 5).

6. Problems of color rendering (and contrast effects) were already known by the classical Greeks: ''In woven and embroidered stuffs the appearance of cotton is profoundly affected by their juxtaposition with one another, and also by differences in illumination. Thus embroiderers say that they often make mistakes in their colors when they work by lamplight, and use the wrong ones.'' Aristotle, Meteorologica III, 2,4, quoted from MacAdam, D.L., op.cit.

7. As we have seen in Chapter 3, there are actually two closely spaced bands present. Due to the simplicity of our experimental arrangement we cannot resolve them.

8. A famous example of colored shadows was described by the German poet and color enthusiast Johann Wolfgang von Goethe (1749-1832). See Goethe, J.W., *Color Theory (Farbenlehre),* translation by C.L. Eastlake, Cambridge, Massachusetts: The MIT Press, 1970.

9. Scientifically, complementary colors are those which, by suitable mixture of the stimuli involved, produce an achromatic color sensation (see Chapter 6).

5

Orderly Arrangements of Colors

According to the opponent-color theory there are six fundamental color sensations: red, green, yellow, blue, white, and black. Linguistics indicate that in the more developed societies there are eleven basic color terms. In addition to those mentioned already there are pink, orange, violet, brown, and gray.[1] Investigations have shown that we can recognize from memory a few hundred color sensations, and estimates for the number of color sensations that we can distinguish from each other when seen side by side are in the millions.[2]

There is an apparent hierarchy of color sensations ranging from a fundamental six; to nearly double that number, for which we have created unique words in our languages; to a few hundred that we can recognize as distinct colors when presented individually; to some millions that we can distinguish from each other when presented in pairs or in larger numbers. How to place these sensations in an orderly arrangement has been for centuries (and continues to be) of concern to workers in the color field. To recognize some of the difficulties involved let us visit a fabric store (we could have visited a flower shop or one of many other locations)[3] and have the owner give to us small cuttings of all the fabrics he has in store. For simplicity's sake we sort out from these all samples containing more than one color in form of yarns or printed patterns (more exactly, where different color

stimuli result from viewing a small sample). We may be left with some two hundred samples. How do we arrange these by color in an orderly fashion? For a start we may sort them according to their opponent-color hues: yellow, red, blue, and green and the hueless group of white, black, and intermediate grays. We may have not much difficulty separating the oranges between yellow and red and the violets between red and blue as they will generally appear to contain more of one or the other of these components. Similarly, we have little difficulty assigning navies, olives, and burgundies. They quite clearly belong to blue, green, and red respectively. But we may have a problem in assigning browns. They seem to represent a group of color sensations of their own and are not easily recognized as blackish yellows and oranges.

Concentrating on the samples producing color sensations without hue, we recognize that they form a one-dimensional scale with black and white at the extremes and grays arranged inbetween according to their resemblance to, or difference from, black or white. Such a scale (we will temporarily call it a whiteness scale) is absolute in nature since it begins at zero whiteness (black) and ends at infinite whiteness (white). It could also be seen as an antagonistic scale with a neutral position between white and black, a gray that seems to contain equally as much white as black.

Moving to hued samples we quickly run into conceptual difficulties. Taking red as an example (red in its basic form, unique red) we may attempt a similar scale as the whiteness scale, from full red to no-red. But what is no-red: white, black, or a gray? In our sample collection we may find samples with the hue of unique red (neither bluish nor yellowish) but containing various amounts of whiteness or blackness. We can arrange these samples in a two-dimensional diagram where whiteness is plotted against redness. But because of the opponent character of white and black it appears to be more practical to assign to blackness the same status whiteness and redness have and to arrange the colors in an equilateral triangle with the coordinates white, black and red (Figure 5-1). Along the three sides we have scales of white to black, white to red, and red to black with the area within

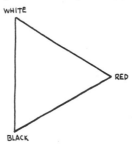

5-1. Equilateral triangular arrangement of samples with an unique red hue based on their redness and whiteness (or blackness).

the triangle representing colors that contain whiteness, blackness, and redness. The geometrical position of red as halfway between white and black has no meaning.

Another way is to resort to the concept of lightness (see Chapter 4). We recall that lightness is the attribute of a visual sensation according to

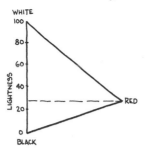

5-2. Triangular arrangement of color samples with a unique red hue according to redness and lightness.

which an area appears to reflect a greater or smaller amount of light falling on it. We now find it possible to arrange all samples with a unique red hue two-dimensionally according to redness and lightness. We may judge our full red sample to have a lightness of 40 (on a scale of 0 to 100, with white having a lightness of 100 and black one of zero). It is in this respect equal to a gray with the judged lightness of 40. The result is a triangular arrangement with the sides being unequal in length (Figure 5-2) The position of red on the vertical (lightness) axis now has meaning and the triangle can be seen as having the geometrical dimensions of lightness and redness. Similar triangles can be arranged for the other three unique hues and in fact for all other samples of a given hue.

Unique red and unique green are called opponent colors because they are most unlike. There are red colors containing yellow and others that contain blue, but there are under identical viewing and surround conditions no red colors seen to contain green. For this reason we can arrange the redness/lightness and the greenness/lightness triangles in a plane opposite

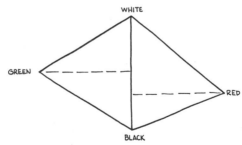

5-3. Arrangement of redness-lightness and greenness-lightness triangles at right angles with a common lightness axis.

to each other (Figure 5-3). In a similar fashion we can arrange the blueness/lightness and the yellowness/lightness triangles. Next, we erect the resultant rhombi at right angles to each other with a common, vertical no-hue axis (Figure 5-4). The right angle can be justified on the basis that, say, unique yellow is equally far removed from unique red as from unique blue. The remaining mixed-hue triangles can be fitted into the four open areas of the tree-like structure in a logical manner. The triangles containing red and yellow are arranged between the unique red and unique yellow triangles according to their content of redness, yellowness, and so forth. The result is

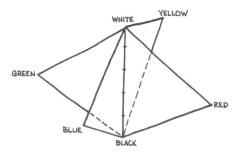

5-4. Arrangement of the four unique hue triangles at right angles with common lightness axis.

a three-dimensional arrangement of our color samples built in a logically consistent manner, a color space or color solid. If we look down at our model from above we note that the hues form a circle, with the unique hues at opposite ends of a cross (Figure 5-5) and the hueless color in the center.

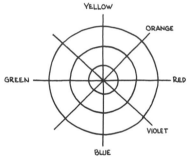

5-5. View of the "color-tree" from above, illustrating the hue circle. Colors with equal chroma are situated on concentric circles.

The model quite obviously has geometrical properties; we have called it three-dimensional. But what are the dimensions associated with width and depth? In the three-dimensional arrangement hue cannot be a dimension as it is circular and has no beginning and end as seen in Figure 5-4. In order to have a color space with dimensions that have a perceptual meaning we have to separate our model into four subspaces along the unique hue lines. Each of these four subspaces now has identifiable dimensions. Figure 5-6 illustrates the yellowness-redness-lightness subspace. Height corresponds to lightness, width to yellowness and depth to redness. The depth dimension, for example, begins at zero redness and proceeds to full redness. Figure 5-7 illustrates the plane containing all colors with ten percent redness. Despite the fact that the geometrical dimensions width and depth loose their perceptual meaning, it is common to consider all four subspaces joined together as one color space.

While we have described a valid blueprint for a color solid, there is actually no system in existence exactly as described. The idea of redness or blueness as dimensions ranging from zero to one hundred is not one that is being used. Hue is considered a dimensionless quality. We have seen, however, that all our fabric samples can be placed into a three-dimensional

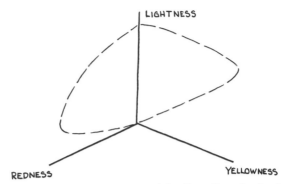

5-6. Schematic representation of the three-dimensional yellowness-redness-lightness space. Colors of the two unique hues having maximum chroma are situated on the dashed lines.

arrangement so that the color sensations they produce (under standard conditions) have a logical order. But only one dimension of this solid, height, has a real meaning in terms of color sensation; its correlate is lightness. The other two dimensions of the solid, width and depth, have no perceptual reality, that is, there are no color attributes corresponding to them. To specify colors two additional attributes of color sensation are used: hue, forming

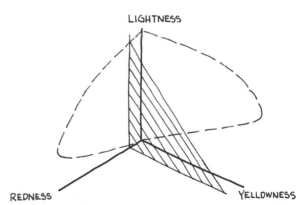

5-7. Schematic representation of the yellowness-redness-lightness space. On the plane depicted by dashed lines all colors containing a fixed amount of redness (ten percent, for example) are located.

a circle in the plane placed at a right angle to the lightness dimension, and chroma, increasing radially from the no-hue central color. It is therefore correct to say that color has three attributes and the color solid has three dimensions, but only one attribute coincides with a dimension. So far we have limited our discussion to related colors. Unrelated colors must also fit into our general scheme (with the achromatic attribute becoming brightness instead of lightness).

We can imagine a perceptual color space built into our cognitive system containing in the same logical arrangement all the color sensations of which we are capable.[4] Most of these sensations can be created by many

different stimuli (the stimuli involved are metameric) or a given stimulus can produce different sensations (if it is presented in different surround conditions). This again points to a very fundamental problem: the stimulus does not stand in a simple relationship to the response. By knowing just the stimulus we are unable to easily predict the response. In attempts to quantify our built-in color space and to exemplify it with physical samples, the complexity of the situation has always been reduced by using single stimuli with a more or less controlled surround: the spectral power distribution of daylight after it is reflected from colored sample, attached to a "gray" background material. If light source or surround is changed, the sample collection is likely not to conform anymore to the original design of the collection. This effect is being counteracted to a certain extent by the adaptation process.

Such sample collections, of necessity, offer only a limited representation of our concept of a color solid, limited to related colors and by the availability of suitable colorants. Another limitation is the number of samples. It is impractical to prepare, even for a limited expanse of the color solid, samples representing all possible color sensations. The next question to be answered, then, is what kind of sampling plan should be used. It is obvious that we can prepare sample collections according to many ideas. Fundamentally, there are two kinds of plans for regular samplings:

—a plan such that the samples represent equal intervals of some sort of stimulus
—so that they represent equal intervals of the response.

Color Space Samplings with Equal Intervals of the Stimulus

The color stimulus is normally a particular spectral power distribution of light, and in the case of related colors is a function of the light source and the spectral reflectance characteristics of the object. It is impractical to change the light source in a systematic way without an elaborate apparatus, but the reflectance characteristics of materials can, within limits, be changed relatively easily with the help of colorants. A given colorant in a given medium, say a "blue" pigment in a paint vehicle, when applied in various concentrations produces color perceptions differing generally in all three attributes— hue, chroma, and lightness. The resulting colorations, or those of mixtures of the "blue," a "white," and "black" pigment, normally will not produce color perceptions that fall on a plane in our three-dimensional color space. By systematically varying the concentrations of pigments or dyes in mixtures

we end up with samples producing stimuli varying in a regular manner as regards the colorant concentrations, but the variations are not related in a simple way to the perceptual variables hue, chroma, and lightness. A sampling of the color solid resulting from such mixing of colorants may not be very meaningful in terms of perceptual variables but it has use and practical value in regard to the color stimuli that can be produced with certain colorants by their systematic mixture. Colorant mixture follows physical laws (they will be discussed in some detail in Chapter 8). Color stimulus mixture, on the other hand, follows perceptual laws.[5] The two are quite different.

Changes in stimuli (the spectral power distribution arriving at the eye) are possible by color stimulus mixture as well as by colorant mixture. An example of the former, even though involving colorants, uses Maxwell's disk.[6] It consists of a disk with sectors colored with colorants. The disk is spun rapidly; because of the inability of the visual system to resolve the individual sectors of the spinning disk, a time-weighted average results, and the total stimulus is the sum of the individual sector stimuli received per unit time. The fractions of the total disk stimulus that the individual sector stimuli represent, are, in turn, proportional to the relative sector areas. The effect of the spinning disk is that the stimuli coming from the individual sectors are being mixed, resulting in a combined total stimulus. By systematically varying individual sector stimuli, both in quality and quantity, regular color samplings in terms of stimulus can be produced.

A similar effect can be achieved by presenting arrays of color stimuli where each stimulus is of such small size that it cannot be individually resolved. In terms of the visual system this means that photons from various stimuli have an equal chance of arriving at and being absorbed by a given cone in the retina. The total stimulus is, therefore, the area-weighted average of the individual stimuli. Practical examples are found in color television and, more important for our discussion, in halftone printing. The total color stimulus from a printed area is the sum of the individual dot stimuli and is a function of their relative areas. The resulting color stimuli are made more complicated by the fact that in general practice some overlap of printed dots occurs, especially in halftone printing with four inks, and the result is not purely color stimulus mixture but also colorant mixture. In such cases the stimuli vary regularly as a function of technical parameters, but the changes result in changes in sensations where all three visual attributes vary simultaneously. Even more complex relationships are obtained in the case of colorant mixtures, such as pigments in paints or dyes on textiles, where the colorant concentrations are systematically varied. The resulting scales are of interest to the technologist in terms of the color sensations that can be produced with certain colorants, but leave something to be desired as instructive examples of an orderly sampling of color space.[7]

It is, in principle, possible to prepare a sampling of color space purely on the basis of color mixture. In other words, color stimuli can be produced in a regular fashion with the help of Maxwell's disk and can be matched with, say, pigments in paints to produce colored chips representing the original disk stimuli.[8]

Color Space Samplings with Equal Interval of Response

Because of the primacy of sensations in the experience of color, the desire for samplings of color space according to basic attributes of sensation is understandable. We have earlier recognized these attributes to be hue, chroma, and lightness. We can conceive of scales where only hue changes, others where chroma changes while hue and lightness remain the same, or where only lightness changes. Alternatively, we can conceive of scales, in the opponent-color perspective, of redness-greenness, yellowness-blueness, and blackness-whiteness, or lightness. The two scaling plans apply to the same perceptual color space but are intrinsically different. The question remains as to what principle should guide the selection of intervals of such scales. We have at least two possibilities, a choice of absolute intervals in terms of, say, redness or blackness and a choice of relative intervals in terms of difference.

To illustrate the two principles in the case of hueless colors we can scale such colors by judging the absolute amount of whiteness they contain, or we can scale them by judging intervals so that the perceived distance from one to the next along the scale is always the same. Both are valid scaling techniques. Since no experiments have been run comparing the two techniques under otherwise exactly identical conditions, it is not known how much the two scales would differ. Available data indicates that they are quite similar. The former technique relies on a concept of whiteness (or redness, etc.), knowledge of which is innate to the observer, against which the content of whiteness of a given color sensation is judged. In the latter case the observers' ability to judge the size of a difference in sensations caused by two color stimuli against the size of another such difference is used. If our general ability to distinguish between color sensations is a guide, the latter method should be more precise. It is apparent (see Chapter 1) that there are two different scaling principles involved in the two cases. The absolute judgment of the magnitude of a perceptual variable leads to a ratio scale, while the judgment of the magnitude of the difference leads to an interval scale.

We recognize that there are several valid principles that can guide us in developing a scaling plan of perceptual color space. This fact and the fact that the originator may want to incorporate other principles into the sampling of color space indicate the potential for a number of competing sampling systems. Assuming that such competing systems have been developed with equal care, the choice among them becomes a matter of preference and application. It also should be possible to express the scaling of one system in terms of another. The situation is somewhat similar to that of choosing a number system: depending on the application, we may prefer a binary to a hexadecimal or decimal system. With any of these we can operate in the world of numbers and each can be related to the other.[9] The historical preference for scaling of perceptual color space with difference scales is

probably due to the technological interest in color differences and their quantification. A three-dimensional arrangement of color samples in which each sample is perceived as being equally distant from its nearest neighbors has many practical uses. Before a description of two important attempts to scale color space by the concept of equal perceived differences is given, a system based on magnitude judgments will be outlined.

The Swedish Natural Color System (NCS)

A modern example of absolute scaling of perceptual color space is the NCS System.[10] Its coordinate system is represented by the four unique hues and by black and white. Its scaling is based on the idea that all color sensations

5-8a. Representation of the color triangle of the Natural Color System, in which W = white, S = black, C = maximal color, s = blackness, and c = chromaticness (or degree of similarity to maximal color).

can be judged to be the sum of six basic perceptions white, black, red, green, yellow, and blue, with only four for a given color. The other idea is that each observer has an innate concept of redness and other fundamental sensations, not only in terms of hue but also in terms of quantity. Thus, while available colorants may not make it possible to prepare a physical sample of "fundamental red," the resemblance of any red-containing color to this red can be judged. Each color can be judged as a sum of individual resemblances, with the sum always being 100. An orange may consist of 30 yellow, 30 red, 25 white, and 15 black, where the numbers indicate the degree of similarity to the fundamental sensations of that name. They do not

5-8b. Representation of the color circle of the Natural Color System, with the four unique hues yellow (Y), red (R), blue (B), and green (G), and the intermediate hue steps.

refer to concentrations of colorants. Such resemblances can be judged quite accurately even by untrained observers, a useful ability when color sensations have to be classified in situations where instrumental stimulus measurements are difficult or impossible. In the NCS System, the colors of a given hue are arranged in equilateral triangular form (Figure 5-8a), with white, black, and the fundamental color hue in the corners. The hues are arranged in a circle with the unique hues forming the coordinate system. Ten hue steps lead from one fundamental hue to the next (Figure 5-8b), and ten steps divide the sides of the triangles. Figure 5-8a illustrates the directions of increasing blackness, increasing whiteness and increasing chromaticness. In the NCS system, the latter is a term for the degree of similarity to the hued fundamental color and is comparable to what is commonly referred to as chroma. The term *saturation* is also used in the system but denotes colors of increasing chromatic proportion, or colors have the same saturation in the NCS System if the ratio of chromatic to achromatic similarity is the same. Such colors form what is known as a shadow series, colors of an object seen under increasingly shaded condition.

The NCS System contains over 2000 color specifications (66 per triangle for 40 equal-hue triangles), and 1,412 of these have been realized in the form of painted paper samples (limited because of the lack of suitable colorants). These samples, of course, represent the notations only under standard conditions of illumination and surround. The system makes no claims for perceptual uniformity of the differences between the sensations caused by the samples. Even though technological aids (reflectance measurement and calculation) have been used in the realization of the system, its concept and use rely on the observer only. For this reason it is particularly popular with nontechnological users such as designers, artists, and craftsmen as well as in general situations calling for color description where instrumental measurements are difficult to make.

PLATE A An artist's rendition of the appearance of the visible spectrum.

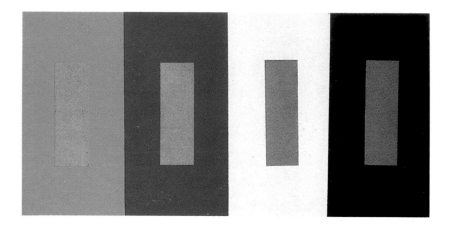

PLATE B An example of simultaneous contrast. Despite the differences in appearance, the gray bars in all four fields are identical. The red and green surrounds induce mainly changes in apparent hue of the gray bars while the white and black surrounds induce changes in apparent lightness.

PLATE C Examples of successive contrast. Fix your gaze for
thirty to sixty seconds on the black dot in the center of one of
the colored squares while covering the other with white paper.
Rapidly change your gaze horizontally to the black dot in the
corresponding white square. The white square will assume a
distinctly bluish hue in case of the yellow square, a greenish
hue in case of the red square. See Chapter 4 for further dis-
cussion.

PLATE D A view of a model of the Optical Society of America-Uniform Color Scales system. See Chapter 5 for further explanations. Photograph courtesy of D.L. MacAdam.

The NCS System, based on six fundamental sensations, fits into an Euclidean geometrical (conventional three-dimensional) space. In a system based on equally perceptible differences, difficulties are likely to arise in this respect, as we will see. Equally perceptible differences can be judged at the level

> —of just-perceptible differences, i.e. those that are just visible
> —where the differences are somewhat larger, such as those typically found in the manufacture of colorants and colored goods
> —where the differences are relatively large.

Based on existing evidence the three types of evaluation will not lead to results that completely mesh. That is, color differences may not be truly additive. Furthermore, there are various techniques for establishing equality of differences, some of which are

> —continued halving of an originally large difference
> —ratio estimates based on a grid of samples presented
> —absolute judgment of a difference or judgment against a displayed reference difference.

There is a question as to whether these and other possible techniques of evaluation will yield the same result.

The results of judgments of differences of related colors are also known to be affected by the level of illumination, the sensation caused by the surround, the state of adaptation, and the separation between the colored samples. It is apparent that there is considerable elasticity in our perception of color differences depending on conditions. While it may be possible to represent the results of judgments for one given set of conditions in an Euclidean space, this may not be possible anymore in the same space if conditions are changed.

An "ideal color space" would have perceptually meaningful Euclidean coordinates and attributes, with differences equidistant at all levels of size of color difference. Indications are that the ideal color space may not exist, that indeed as one moves (to use a metaphor) from the universe to the earth (the localized color space) to one's own backyard plot, new rules and geometries apply. It has become apparent that the question of a logical arrangement of colors is intermeshed with the problem of color differences. Experimental evidence available so far indicates that the results of global scaling (the scaling of all color space according to basic attributes) and scaling on the basis of small or just noticeable differences (top-down, so to speak, as in the former case, or bottom-up, as in the latter) do not mesh neatly. The reasons are not understood and may be many.

This lack of agreement appears to be of little but cosmetic practical significance. Global color scaling is used for color identification and specification as well as color naming according to some orderly scheme. Color differences are of particular interest in industrial colorant application. It is simply an inconvenience if the same schemes and geometrical models cannot be used in both applications.

The Munsell Color System

Perhaps the best-known color order system in English-speaking countries is the Munsell Color System.[11] It is a cylindrical system based on the three attributes: hue, chroma, and value, *value* being the Munsell designation for *lightness*. Hues are arranged in a circle sectioned by five basic hues. The reason why five hues were chosen appears to have had to do more with the general numbering system used (a decimal system) than with any perceptual need. The hue circle is separated into one hundred steps visually equidistant from each other. Only the unique red hue coincides well with the corresponding basic hue of the Munsell system. An important reason for the lack of correspondence is that the number of visually equal difference steps of standard size between unique hues varies. In terms of the one hundred equal Munsell steps, they are approximately:

Hue sector	Munsell hue steps
red to yellow	23
yellow to green	18
green to blue	28
blue to red	31

It is therefore not possible to construct a color space using the unique hues as coordinates and having an equal number of unit sized difference steps between them. The perceptual size of the hue steps depends on the chroma of the colors, as is apparent from Figure 5-9. This figure illustrates the Munsell hue circle at a given level of value and various levels of chroma. It is evident that the perceptual hue difference between two neighboring hues is larger at high chroma than at low chroma, a condition that tends to be a drawback of cylindrical arrangements of colors.

The chroma scale is open ended, starting at zero chroma in the center and radially increasing. Practical limits are set by the availability of suitable colorants to produce high-chroma colored samples. The absolute limits are the theoretical limits of chroma for related colors of a given hue and lightness (see also Chapter 6). Unrelated colors of highest saturation are the spectrum colors.

The value scale ranges from 1 (black) to 10 (white), with nine perceptually equally sized intermediate steps of gray.

The Munsell system includes an identification scheme for colors. A complete designation is given as hue-value/chroma, 7BG 5/4, indicating a bluish green color of hue 7BG, value 5, and chroma 4. A given hue designation indicates that all colors of this designation have the same hue, regardless of chroma or value. In a corresponding manner this also applies to colors of a given value or chroma. The colors of the gray scale are indicated by the letter N, so N7 is a gray of value 7. This arrangement allows

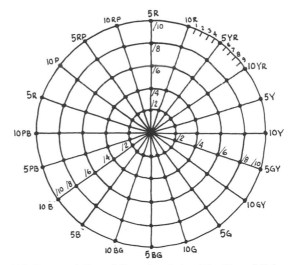

5-9. Representation of the color circle of the Munsell Color System, with the five basic hues yellow (Y), red (R), purple (P), blue (B), green (G), and the intermediate hue steps. Colors of equal chroma are located on the concentric circles, with chroma value indicated by the number following the / sign.

interpolation and extrapolation, that is, colors between and beyond those illustrated in the form of painted paper chips in the associated *Munsell Book of Color* can be specified. The *Munsell Book of Color* illustrates 1450 colors arranged in 40 hue planes, at single value and double chroma steps. A schematic sketch of the system is shown in Figure 5-10.

The spacing of the Munsell system has been arrived at against a relatively light gray surround. Because of simultaneous color contrast and adaptation effects (see Chapter 3), certain distortions occur for dark colors: the value and chroma spacings for dark colors would be somewhat different had the surround been a dark gray. Under those conditions, a changed spacing would have been obtained for light colors.

The chips representing the colors of the *Munsell Book of Colors* have been prepared for viewing in daylight. A change to any other light source can potentially distort the system since another source will produce different stimuli and perhaps different responses. Care has been taken in the selection of colorants used for the Munsell chips so as to reduce distortions in the system when the chips are viewed in "white" light other than daylight.

Investigations have shown that the three color attributes on which the Munsell system is based—hue, value, and chroma—have real perceptual meaning once they are explained to the observer, even to observers untrained in visual scaling. They are easily visualized and comprehended, which is a major reason for the popularity of the system.

An effort to overcome some of the drawbacks of the Munsell system, in particular the dependence of the hue differences on chroma as well as the nonrelatedness of the hue, value, and chroma scale (the unit size of the

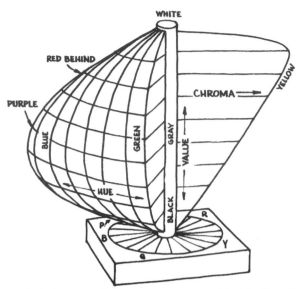

5-10. Schematic view of a geometrical model of the Munsell Color System, with a section removed for clarity.

difference in one scale is not the same as in another) has led to the development of another system based on equality of difference, the Optical Society of America Uniform Color Scales.

The Optical Society of America Uniform Color Scales (OSA-UCS)[12]

The question of how to sample perceptual color space in the most uniform manner leads us to consider crystalline structures in which atoms or molecules are arranged so that they fill the available space optimally. Such an arrangement can be considered as a geometrical model for a uniform arrangement of color sensations. For the purpose of discussion we use spheres as geometrical correlates of colors. The point at the center of the sphere represents a given color sensation and points on the surface of the sphere represent half the uniform distance to neighboring color sensations. In such an arrangement, selected colors equidistant from their neighbors are represented by spheres of equal size. The diameter of the spheres is representative of the size of the distances chosen for the arrangement. If we consider colors in a given plane we find that the spheres pack themselves in the most dense arrangement in rows, with the spheres offset in adjoining

5-11a. Spheres representing colors equidistant from their nearest neighbors in closest possible packing on a plane, with the triangular grid of their centers and the hexagon of the six nearest neighbors around the central color (in gray).

rows by the length of a radius (Figure 5-11a). Taking a particular sphere as representing the standard color, we find that there are six neighbors, those nearest, forming a hexagon. The general arrangement is triangular with the perceptual difference equal for any side of any triangle. When moving to a higher plane in a manner that maintains equality of differences and tightest packing, we notice that there are only three nearest neighboring colors (Figure 5-11b). A comparable situation arises when moving to a lower plane.

5-11b. The three spheres that are nearest neighbors in closest possible packing on the next higher plane. The central color and its six nearest neighbors on plane L are shown in dashed lines; three nearest neighbors on plane L + 1 are shown in solid line.

Upon connecting the centers of the spheres of the twelve nearest neighbors (six in the same plane, three at the next higher, and three at the next lower plane) with lines, we obtain a geometrical solid, called a polyhedron, specifically in our case a cubo-octahedron (Figure 5-12a). For the OSA-UCS system, the cubo-octahedron has been rotated as in Figure 5-12b. In the OSA-UCS system, colors are defined by their lightness value L, their yellowness value j, and their greenness value g[13]. Lightness L has a value of zero for a medium gray with increasing positive values for lighter

5-12a. Cubo-octahedron formed by the twelve nearest neighbors equidistant from the central color M.

colors and increasing negative values for darker colors. Real samples range from approximately L= −7 to L= +6. Yellowness *j* ranges for real samples from about j= −6 to j= +12 (blue to yellow). Greenness *g* of real samples ranges from about g= −10 to g= +6 (red to green). Assuming that the illustrated cubo-octahedron is the central one in the color solid, the axes *j* and *g* of the OSA-UCS system in the lightness plane coincide with lines passing through points (colors) labeled E, M, and G in one case and points labeled F, M, and H in the other case. The lightness axis *L* is erected perpendicularly to that plane over the central color labeled M. In the OSA-UCS system colors are defined by their *L, j* and *g* values.

The cubo-octahedron is the basis of the Uniform Color Scales. Its center can be formed by any color in color space except those at the

5-12b. The same cubo-octahedron rotated forty-five degrees (in the direction of the viewer), with axes conforming to those of the OSA-UCS system. Colors E,F,G, and H have the same lightness as central color M; colors I,J,K, and L are on the next higher lightness plane while colors A,B,C, and D are on the next lower plane.

periphery of the space. This is illustrated schematically in Figure 5-13, which shows three interlocking cubo-octahedra, with each point representing the place of a color equally distant from its twelve nearest neighbors. It can be visualized that comparable cubo-octahedra can be formed around any of the points as long as they are not on the periphery of the space. The three planes illustrated would require a rotation of forty-five degrees so that the axes of the cubo-octahedron conform to those chosen for the OSA-UCS system (recall Figures 5-12a and 5-12b).

The samples in a given lightness plane in the system form squares, the squares in the next higher or lower lightness plane being offset by half the

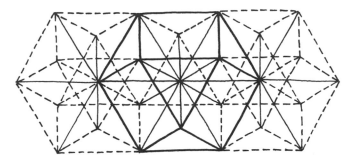

5-13. Cubo-octahedron with two neighboring cubo-octahedra in the same horizontal plane.

length of a square. It is evident from Figure 5-12b that equidistant hue scales are formed only from the center point in the direction of the major hue axes. Nearest colors on the next higher or lower lightness planes are different from the center color not only in lightness but also in hue and chroma. These facts make for some difficulties in orientation in this system.

We have seen that a triangular lattice in a plane (called a regular rhombohedral lattice) for all three dimensions of color space produces a very uniform sectioning, resulting in the maximum number of equal differences. There remains the question of the perceptual reality of the color cubo-octahedron, that is, do equal differences determined individually "add up" to close the triangles or the more complex geometrical structures? Experiments have shown that this is not completely the case, that in a hexagonal arrangement, for example, the color differences between the center color and those at each of the corners of the hexagon as well as those between neighboring colors on the periphery of the hexagon will not be completely additive. This indicates some fundamental difficulty of embedding color differences, visually judged to be equal in various directions from the standard, into simple Euclidean space. The discrepancies are relatively small, however, small enough to be neglected or adjusted for.

A particular property of a regular rhombohedral space-sectioning system such as that described is the fact that it contains seven different cleavage planes within which the differences between colors are equal. The Munsell system has such a cleavage plane only in the value (horizontal) direction. Using the letter designations of the colors in Figure 5-12b the corresponding plane is formed in the OSA-UCS system by colors labeled E,

F, G, and H (all having equal lightness). The other six planes in this system are formed by colors as follows:

Plane 2	B, F, I, K, H, D
Plane 3	A, F, J, L, H, C
Plane 4	I, J, G, D, C, E
Plane 5	K, L, G, B, A, E
Plane 6	I, A, D, L
Plane 7	J, B, C, K

A plane such as plane 2 (or any of its parallel planes) bisects the complete color solid and opens a view of colors, equally distant from each other, that is new. Note that, except for the cleavage plane in the lightness direction, none of the planes coincides with a fundamental color attribute. The vistas such sectioning produces are a by-product of the geometrical structure selected. A particular use for them is not immediately apparent. They have been called esthetically pleasing by some of the creators of the system but esthethics are, of course, basically in the eye of the beholder. Future work may discover hidden harmonic principles and a usefulness for artists and designers.

The OSA Uniform Color Scales have been illustrated with a collection of 558 painted samples, filling at regular intervals most of the portion of perceptual color space that can be covered by the use of colorants. Care has also here been taken in the selection of colorants used so that the samples represent the intended sampling reasonably well even if viewed with conventional fluorescent office lighting or in the light of an incandescent bulb, rather than in daylight. Plate D illustrates an assembled model of the OSA-UCS system. Each sphere represents a color from the sample collection. The lattice arrangement and some of the cleavage planes are clearly visible.

The Munsell system and the OSA Uniform Color Scales represent attempts to scale perceptual color space by two different approaches based on equality of differences. One would expect the results of the two approaches to be convertible. Comparisons have shown that the two systems coincide reasonably well, but not exactly. A typical example of such comparisons is shown in Figure 5-14: at medium lightness the colors caused by the OSA-UCS samples are plotted on a Munsell hue/chroma diagram. If the systems are related in a simple way, a uniform grid of the OSA-UCS samples should result. The disagreement shown may have many causes and it is not apparent which of the two systems is more accurate. Future scaling efforts may decrease these discrepancies.

The Munsell system can point to a considerable tradition. It is easy to comprehend, as it is based on three easily understood perceptual attributes. The OSA-UCS system may perhaps claim a more rational structure and a better-designed experimental basis, but suffers somewhat from a difficulty, the difficulty inexperienced users are likely to have in orienting themselves in the system.

Orderly arrangement of colors is not a completely solved problem. A number of aspects remain to be investigated further. Uniform spacing, in

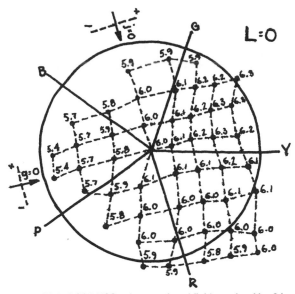

5-14. Plot of OSA-UCS color samples at lightness level L=0 in a Munsell hue-chroma diagram (comparable to Figure 5-9), illustrating the degree of agreement between the two systems. The direction of the principal hue axes *g* and *j* of the OSA-UCS system are indicated by arrows. The numbers next to the dots representing the colors are the Munsell values of the colors.

particular, continues to be a problem. For most practical applications involving an orderly arrangement of colors the three systems discussed seem to offer satisfactory solutions, however.

Color Naming

Once we have arranged all color sensations in an orderly manner, there occurs the task of naming them. At the beginning of the chapter we have indicated that in technically developed societies there normally are eleven basic color terms. These are terms immediately recognizable, having meanings limited to color sensations only. Other color names are often compounded from the basic names (yellow-brown, for example), while others again are derived from the names of objects that normally result in a certain color sensation (charcoal, chocolate brown, sky blue, lime, and so forth). Finally, there is a large number of fantasy color names in use and constantly being coined; these include Cuban Sand, Ashes of Rose, Ophelia, Blue Fox, Moonbeam, and so on.

Basic color terms are not specific enough for many purposes. However, it is evident that it is impossible or impractical to have a specific name

for each existing color sensation. Numerical and/or letter designations are, of course, possible based on any of the three color order systems discussed above (or on others). But such designations are meaningful only to the specialist having extensive experience with them. A simple scheme is therefore desirable to allow the naming of a color with considerable specificity. Such a scheme is found in Level 3 of the *Universal Color Language*.[14] This language has six levels, from the least precise Level 1 to the most precise Level 6. Level 1 consists of 13 terms, the 11 basic terms discussed earlier to which were added yellowish green and olive. Level 2 consists of 29 terms, those of Level 1 plus sixteen additional combination names, such as "purplish pink." Level 3 consists of 267 terms (according to the *ISCC-NBS Method of Designating Colors*[15]), a typical example of which is "light yellowish brown." Modifiers are being added to combinations of color terms, and these include, "light," "strong," "brilliant," "vivid," "dark," "deep," "very," and so forth.

For many practical applications this amount of detail is sufficient and the terms are easily comprehended. Level 4 has approximately five thousand possible designations; it is based on existing sample collections of color order systems (such as the Munsell system) and uses the designations of these systems. Level 5, with some one hundred thousand designations, uses visually interpolated or extrapolated Munsell notation or OSA-UCS notation. Level 6, finally, is fundamentally different from the others in that it relies on instrumental data defining the stimulus and on a direct relationship between stimulus and response. The result is valid only under strict observance of standard conditions. The number of colors that can be distinguished at this level is theoretically endless.

Footnotes

1. For a detailed discussion of the use of basic color terms in many languages see Berlin, B and Kay, P., *Basic Color Terms*, Berkeley, California: University of California Press, 1969.

2. According to Judd and Wyszecki there are at least ten million detectably different colors (Judd, D.B. and Wyszecki, G., *Color in Business, Science, and Industry*, third edition, New York, New York: John Wiley & Sons, 1975).

3. A "desert island" experiment involving colored pebbles on a beach is described in Judd and Wyszecki, op. cit.

4. It is obvious that we do not have a three-dimensional color solid in our brain. All we have is the response of three types of receptors to a given stimulus. But if we want to graphically plot all possible responses of the three receptors (or all possible signals arriving at the visual cortex) we require a three-dimensional representation.

5. The usual terminology for color stimulus mixture is *additive color mixture,* and that for colorant mixture is *subtractive color mixture.* The latter term particularly is not a good one because no subtraction of sensations occurs.

6. This device is named after the English physicist James Clerk Maxwell (1831-1879) for the important use he made of it in his studies of color in 1860.

7. Well-known examples are the *Dictionary of Color,* by Maerz and Paul (1930); the *Nu-Hue Custom Color System* of the Martin-Senour Company, originally developed in 1946; and the *Pantone System* by the Pantone Corporation.

8. Such a system is that by Wilhelm Ostwald, a German physicist and chemist (1853-1932). He also incorporated, however, certain of his theories into the system, but the result has not stood

the test of time well. A realization of the *Ostwald System* was available as the *Color Harmony Manual* of the Container Corporation of America. For a description of Ostwald's work see Birren, F., *The Color Primer: A Basic Treatise on the Color System of Wilhelm Ostwald,* New York, New York: Van Nostrand Reinhold, 1969.

9. In the field of color there are limits to this convertibility, however. These limits may be due largely to the experimental technique used in establishing the scales.

10. The *NCS* system has been described by Hard and Sivik and is available from the Scandinavian Colour Institute, Stockholm, Sweden: Hard, A. and Sivik, L., "NCS-Natural Color System: A Swedish Standard for Color Notation," *Color Research and Application* 6 (1981), pp. 129-138.

11. The *Munsell Color System* is available from the Kollmorgen Corporation, Newburgh, New York.

12. The *Optical Society of America Uniform Color Scales* have been described by MacAdam and Nickerson, and are available from the Optical Society of America, Washington, D.C.: MacAdam, D.L., "Uniform Color Scales," *Journal of the Optical Society of America* 64 (1974), pp. 1691-1702.
Nickerson, D., "OSA Uniform Color Scale Samples: A Unique Set," *Color Research and Application* 6 (1981), pp. 7-28.

13. The letters *L* and *g* were chosen for obvious reasons, the letter *j* was selected from the French *jaune,* for *yellow,* in order to avoid confusion because of the widespread use of *y* in the CIE system (see Chapter 6).

14. The *Universal Color Language* is described by Kelly, K.L. and Judd, D.B., *Color: Universal Language and Dictionary of Names,* Washington D.C.: U.S. Government Printing Office, National Bureau of Standards Special Publication 440, 1976.

15. See Kelly, K.L. and Judd, D.B., *The ISCC-NBS Method of Designating Colors and a Dictionary of Color Names,* Washington D.C.: U.S. Government Printing Office, National Bureau of Standards Circular 553, 1955.

6

Quantifying the Color Stimulus

In order to assess the relationship between stimulus and response, it is necessary for both of them to be quantified. Quantification in numbers is desirable so that the relationship between stimulus and response can ultimately be expressed in form of mathematical equations. The question arises: at what point should the stimulus be quantified? So far we have used the general term *stimulus* to mean the spectral power distribution arriving at the eye. But the stimulus could also be considered to be the electrical impulses generated in the retina or in the lateral geniculate nucleus, or LGN (see Chapter 3). Should the stimulus be quantified in the form of radiation as it enters the eye, as it strikes the retina, as it is created in the rods and cones or, perhaps, in the opponent-color form as it arrives at the visual center of the brain? The measurement problem in the first case would be relatively simple, the needed measurement is that of the spectral power distribution of light about to enter the eye. The second possibility would require, in addition, knowledge of the average absorption characteristics of the ocular media. A major problem would remain unresolved, however. As we have seen earlier (see Chapter 4) it is possible for many different spectral power distributions to produce identical color sensations. Such stimuli are termed metameric. An orange color sensation, for example, may be caused by a single wavelength stimulus of, say, 590nm, or it may be caused by a suitable mixture of

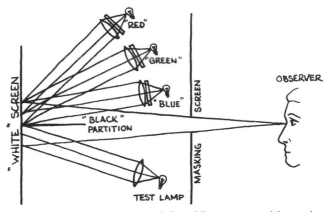

6-1. Schematic representation of the arrangement for a color matching experiment. The color sensation caused by the reflection of the light of the test lamp from the screen is matched by one caused by light mixed by adjustment of the intensities of the three primary lights, R,G, and B.

two single wavelength bands, say 580nm and 610nm. It may also be caused by a broad band stimulus involving all wavelengths from 550nm to 700nm. To cause a sensation of gray an endless number of physical stimuli can be used. To know the physical stimulus at the surface of the retina, therefore, does little to quantify the color stimulus (that leading directly to the sensation). We need to know in addition the laws of color stimulus mixture to be able to determine which stimuli produce identical color sensations (always under a particular set of standard viewing conditions). Color stimulus mixture in the sense of adding two or more physical stimuli together can be studied by using Maxwell's disk or with a set of light projectors capable of projecting colored stimuli onto a given area of a screen. In such color stimulus mixture experiments the observer is typically presented with two adjoining half-disks of projected light, surrounded by a large hueless field. One half-disk is filled with light from one projector while the other half-disk is struck by light from two or more additional projectors (Figure 6-1). An experiment may involve a stimulus from the left half-disk causing an orange sensation, while on the right half-disk light causing a yellow sensation can be superimposed on light causing a red sensation for a combined reflected stimulus. The observer adjusts the quantities of the yellow- and red-producing beams until the resulting sensation matches that caused by the light from the right half-disk. Matching experiments such as these result in the finding that all color sensations can be matched (in a way) by a mixture of no more than three suitably selected physical stimuli. The most surprising result, for uninitiated observers of such matching experiments, is probably the fact that combining a green-causing stimulus with a red-causing stimulus produces a yellow sensation.

By trial and error we find that the greatest number of color sensations can be matched by choosing a "red," a "green," and a "blue" light as the basis of our mixtures (as primary colors). These lights can be represented graphically in a three-dimensional system (as in Figure 6-2a). The three

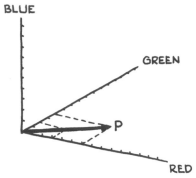

6-2a. Schematic view of a three-dimensional vector space with axes representing the three primary lights, R, G, and B. The vector P represents a color additively mixed from six parts of "red" light and four parts of "green" light.

axes represent the primary lights, scaled arbitrarily from zero (no intensity) to ten (highest intensity). A given combination of primary lights can be illustrated in this scheme by what is called a vector.[1] Mixing six units of "red" light with four units of "green" light results in a light (and a sensation) represented by the arrow (vector) P. The direction of the vector in the three-dimensional system is an indication of the quality (the hue) of the resulting sensation, its length one of its quantity (intensity). By maintaining the same ratio of the two lights in the mixture (say three parts "red" and two parts "green"), the direction of the vector remains the same, only its size changes. This is in agreement with the visually established fact that the hue does not change but the intensity does. Changing the ratio of the two beams being mixed results in a different hue, indicated by a different direction of the vector in our graphical representation.

It is readily apparent that the system can be used to represent mixtures of all three primary lights (Figure 6-2b). We can graphically illustrate in this system the fact that the resulting color vector is the sum of the individual vectors. We can also predict what intensities of the primary lights are necessary in order to match a given stimulus.

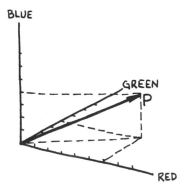

6-2b. Extension of Figure 6-2a to three dimensions. Vector P represents a mix of all three primary lights.

Further experimentation indicates that the sensations caused by certain spectral stimuli presented on the left half-disk can be matched to our three primary lights in hue, but not intensity. This applies to most spectral stimuli causing blue and green sensations. It can be demonstrated, however, that the same basic vector relationship as discussed before is maintained between the stimuli on the two half-disks. By adding a specific amount of one of the primary lights to the left half-disk and thereby reducing the saturation of color perceived on that side, we are now able to adjust the quantities of the remaining two primary lights on the right half-disk so that a match is achieved again. For example, a greenish blue sensation of high saturation such as caused by spectral light of, for instance, 485nm wavelength cannot be matched exactly with any combination of a "blue" and a "green" light. While a hue match can be achieved, the saturation of the mixed stimuli will be lower than that of the spectral stimulus. Matching half-disks can only be achieved by adding a certain amount of "red" primary light to the left half disk to reduce the saturation of the color caused by the spectral light. This can be illustrated in our vector system, as has been done in Figure 6-3. Algebraically, we can consider as negative color the primary light added to the left half-disk since, in effect, we would have to subtract it from the sum of the two primaries on the right half-disk in order to match the original stimulus on the left half-disk. Both situations discussed are encompassed by Grassmann's First Law of color mixture, which states that any color stimulus can be uniquely related to a particular set of three primary color stimuli, as long as each primary stimulus is independent, that is, cannot be matched by a combination of the other two.[2] We need to keep in mind that Grassmann's Law only applies if the two stimuli are presented in close vicinity and under standard conditions of surround and viewing. The specific relationships discovered apply to a particular observer and vary, to a relatively small if significant degree, for other color-normal observers.[3]

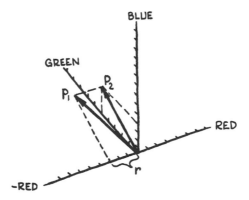

6-3. In this schematic figure the vector P_1 represents a color sensation that cannot be matched additively with the three primary lights. The r represents the amount of "red" primary light that needs to be added to the light represented by vector P_1 so that the two half-disks produce matching sensations. The resulting sensation, desaturated but matching in hue, is represented by vector P_2.

The spectral character of the stimuli creating the matching colors on the right and left half-disks are almost certainly different: their colors are metameric. If we use an additional projector to add an additional stimulus identically to both half-disks of the metameric stimuli, we will find the resulting sensation to have changed (to be of a different color), but the change is identical for both half-disks. For example, a stimulus causing a green sensation, produces (if the correct relative quantities are used) matching yellow sensations when added identically to two metameric stimuli causing identical red sensations. This circumstance is covered by Grassmann's Second Law, which states that stimuli causing matching sensations, continue to cause matching, if different, sensations when mixed with a third stimulus. Additional experiments will show that a change in surround will change the resulting sensations; yet matches between the two half-disks will persist despite the change in the surround. If stimuli creating orange sensations against a gray surround are presented against a much brighter white surround they will now cause a sensation of brown. If the colors caused by the two half-disks were matching before the change in surround, they will continue to do so after.

From the preceeding discussion it becomes evident that we can describe (under standard conditions) each color sensation by amounts of three primary lights required to produce matching sensations. Because of the application of Grassmann's Laws, we need merely to determine the amounts of three defined primary lights required to match the sensations produced by all pure spectral lights. The quantities needed to produce matching sensations for mixtures of pure spectral lights can then be determined mathematically by using these laws.

A typical result of such a matching experiment is illustrated in Figure 6-4. The sensations caused by pure spectral lights from approximately 400nm to 700nm have been matched with mixtures of varying amounts of three spectral lights. The three primary lights used in this experiment have wavelengths of 444.4nm, 526.3nm, and 645.2nm. The reason for this choice is technical; other choices could have been made with the essential results (not the curves of Figure 6-4) being identical. The figure illustrates the amounts of the primary lights, expressed as tristimulus values,[4] necessary to match the sensations caused by spectral lights. It is apparent from the figure that for virtually all color sensations caused by pure spectral stimuli a complete match with these three primary lights is not possible and it is necessary to add a certain amount of one of the primary lights to the standard half disk in order to desaturate it and thus achieve a match. This results in a negative tristimulus value of greater or smaller magnitude for one of the three primary lights at nearly every wavelength. It is particularly evident in the case of blue to green colors caused by spectral stimuli from 450nm to 520nm. They are all more saturated than the sensations caused by mixtures of stimuli of 444.4nm and 526.3nm or any similar "blue" and "green" spectral primary lights. The curves of Figure 6-4 represent, in a way, the average color vision characteristics of humans. The amounts of the three primary lights necessary to match the spectral colors must in some way be related to the response characteristics of the color vision receptors.

Because color matching is an additive process in which under standard conditions the colors caused by two given stimuli add up in a simple

way to produce a third color sensation, the resulting mathematical relationship is also quite simple. Based on this relationship it is possible to mathematically transform the response curves of Figure 6-4 so that they apply to another set of primary lights, making it possible to predict for any given set of primary lights the amounts necessary to produce matching stimuli. New, transformed curves would of course differ from those of Figure 6-4, since

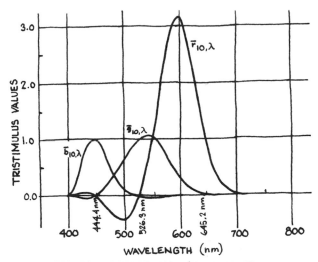

6-4. Average results of matching experiments. The curves represent the amounts of three primary lights of wavelengths 444.4nm, 526.3nm, and 645.2nm to match the sensations caused by spectral lights throughout the visible range. The curves are representations of the CIE color matching functions r,g,b.

other amounts of the new primary lights would be required to match the colors caused by spectral lights. But intrinsically the information (concerning matching stimuli) contained in the curves remains the same. It has been postulated that the response functions of the three cone receptors are related in a simple, linear way (after correction for the absorption characteristics of the eye media) to the color matching functions of Figure 6-4. No definite transformation equations have been proposed, however, because there is no information available that points to a unique transformation, representing the cone response functions. Such response functions should have no negative values and should probably be the most specific, that is, they should show the narrowest spectral response possible based on the color matching data.

Curves that represent linear transformations of the color matching functions and that fulfill such requirements are illustrated in Figure 6-5 and are reasonably representative of cone receptor response functions. The curves of Figure 6-5 have associated with them three primary lights for which the curves represent the tristimulus values, as discussed above for Figure 6-4; there are three primary lights for which these curves represent the amounts required to produce matches for the colors caused by pure

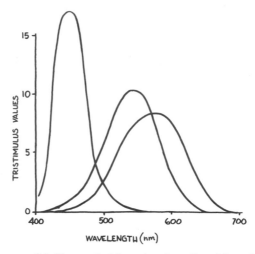

6-5. The result of linear transformation of the color matching functions of Figure 6-4. The curves have no negative lobes and illustrate the most specific response. They may represent the cone response functions.

spectral lights. The corresponding primary lights are nonreal and therefore only hypothetical since all real primary lights lead to partially negative color-matching functions. Because of the proven linear relationship of additive color mixture, these nonreal primary lights are nevertheless valid concepts.

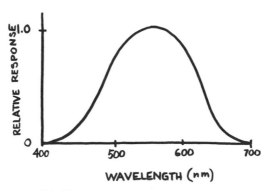

6-6. The response characteristics of a hypothetical receptor.

Color matching functions give us (for the observer to whom they apply) complete information concerning which stimuli produce matching

color sensations. They are all those physical stimuli producing the identical response in the receptor system. Accordingly, it is possible to redefine color in a psychophysical sense (in a system combining physics and psychology) as a set of three numbers representative of that response. These numbers are the product of the stimulus function and the response or color matching functions.

Let us explore this with a simple model involving only one hypothetical receptor. Assume this receptor to have spectral response characteristics as illustrated in Figure 6-6. (This receptor could not lead to color sensation, but only to brightness sensation). One meaning of this curve is that it takes, say, two times the amount of light at 480nm as it takes at 560nm to produce the same response in the receptor. Another meaning of the curve, along lines previously discussed, is that it represents the relative amounts of a single primary light of wavelength 550nm needed to match the sensations caused by the spectral lights of unit amount as seen by an observer having a visual system consisting of one type of receptor only, the one illustrated in Figure 6-6. Identical responses by the receptor are created by, for example, equal amounts of light of 480nm and of 630nm. Equal amounts of light of 480nm and of 550nm, on the other hand, would not produce the same response and would not result in matching sensations.

So far we have considered only light of a single wavelength and its effect on the receptor, but we can extend the situation to a broad band of light. If equal amounts of light of all wavelengths from 400nm to 700nm impinge on the receptor, a certain response is obtained. If fifty percent of these amounts of light of all wavelengths impinge, half of that response is obtained. Identical responses are obtained from the receptor due to the three spectral power distributions illustrated in Figure 6-7, assuming that the total amount of light of the three distributions is identical. Their total response can be calculated from the data describing the spectral stimulus power distribution (the relative amounts of light from 400nm to 700nm) and

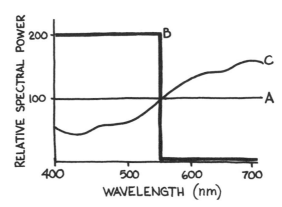

6-7. Three broadband spectral power distributions A,B,C producing identical response from a receptor of response characteristics as illustrated in Figure 6-6.

those describing the spectral response characteristics, by multiplying one by the other at every wavelength, adding the totals for all wavelengths, and suitably scaling the sum.[5] The result, a single number in the case of our simple model, is a psychophysical description of the response caused by a particular spectral power distribution when viewed under standard conditions. On contemplation it becomes evident that the number of stimuli producing matching sensations to that from a given standard stimulus in the case of lights consisting of energies of all wavelengths from 400nm to 700nm is infinite. An endless number of variations of the curves in Figure 6-7 can be created all producing the identical response from the receptor and, therefore, producing matching sensations. Such matching stimuli, to reiterate, are termed metameric.

As we saw earlier, the number of types of receptors responsible for color vision in the human visual system is three. The experimental color matching functions illustrated in Figure 6-4 are the result of the response characteristics of these receptors. Because the negative lobes in these curves create complications in the calculations of the psychophysical color values, a linear transformation such as the one shown in Figure 6-5 was deemed desirable. The CIE, the international guiding body in matters of colorimetry,[6] decided on a transformation of the experimental color matching functions with an additional idea in mind: the transformation equation was chosen so that one of the transformed functions would be identical to

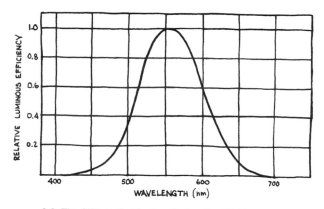

6-8. The CIE spectral luminosity function Vλ. It represents the brightness response of the visual system adapted to normal daylight brightness.

the brightness response of the visual system. Spectral and mixed lights, as discussed earlier, produce sensations not only of hue but also of saturation and brightness (see Chapter 4). The average relative brightness response caused by unit amounts of all spectral lights has been experimentally determined and is illustrated in Figure 6-8. This figure differs from Figure 3-4, in which the brightness response of the dark-adapted eye was illustrated (the so-called scotopic response[7]).

Figure 6-8 represents the brightness response of the eye adapted to normal daylight and is called the photopic response. The transformation of

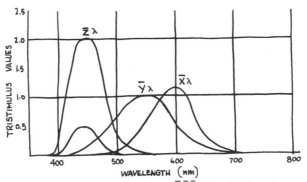

6-9. CIE color matching functions x̄,ȳ,z̄, derived by linear transformation from the experimental color-matching functions of Figure 6-4. The equivalent results of a different transformation are illustrated in Figure 6-5.

the experimental color matching functions of Figure 6-4 has been chosen in such a manner that one of the resulting functions is identical to the brightness response function Vλ.[8] The result of the transformation chosen is represented by the curves illustrated in Figure 6-9. These curves can, again, be seen as representing the relative quantities of three nonreal primary light sources required to match the sensations created by spectral lights. They are called the CIE spectral color matching functions x̄, ȳ, z̄.[9] They fulfill the requirement of having no negative lobes and one of them, the ȳ-function, matches the photopic luminosity function Vλ. The color-matching functions can be used to determine the implied average receptor response due to stimulation by light of a given spectral power distribution, i.e., to determine the psychophysical color values. A unit amount of light of a wavelength of, say, 480nm stimulates the three receptors to approximate relative degrees of 0.1x̄, 0.2ȳ, and 0.6z̄. The scaling that is used for the color matching functions is such that the total response for a given function across the complete spectrum is one hundred. A mixed light consisting of unit amounts of energy across the whole spectrum will produce a relative response of one hundred for any of the three functions. The total response is calculated, as in the case of the single receptor model discussed above, by multiplying the relative intensity of light at a given wavelength with the color-matching function value at the same wavelength and totaling all the resulting products for a given color-matching function. This is graphically illustrated in Figure 6-10. The resulting sums, suitably scaled, are called tristimulus values X, Y, and Z.[10] They represent the areas under the three curves illustrating the calculated products. The three tristimulus values X, Y, and Z are numerical equivalents of the sensations caused by light of a particular power distribution (the stimulus) when viewed by the standard observer under a set of standard conditions. They represent the result of color measurement and, in a sense, are the numerical equivalent of a color sensation.

So far, we have considered only the relative spectral power distribution of the light arriving at the observer's eye. To measure it we require an instrument called a spectroradiometer, which allows direct measurement of the light intensity striking its sensor at a given wavelength. Since colorimetry

is not interested in the absolute intensity, the relative intensity is determined by customarily normalizing the data at 560nm; in other words, the relative energy at this wavelength is set to one or one hundred. The relative spectral power distribution of three typical light sources and of a "red" traffic light are illustrated in Figure 6-11. The corresponding tristimulus values X, Y, and Z are as follows:

	X	Y	Z
standard daylight D6500	95.02	100.0	108.85
tungsten light A	109.85	100.0	35.58
cool white fluorescent	98.15	100.0	67.97
red traffic light	259.30	100.0	11.10

These values were arrived at as illustrated in Figure 6-10: by multiplying the spectral power distribution values of the light source with the color-matching function values, and then totaling the resulting products. Since they apply to light sources having wide spectral bands, the values have been scaled so that the tristimulus value Y is one hundred, that is, the brightness of the corresponding lights is the same in all cases.

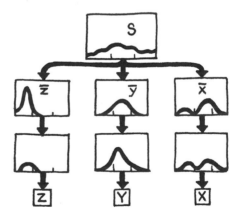

6-10. Schematic representation of the determination of the tristimulus values X,Y, and Z from the spectral power distribution S of the stimulus and the spectral color matching functions x̄, ȳ, and z̄.

For related colors, the stimulus is a function of the spectral power distribution of the light source used for illumination and of the reflectance characteristics of the object illuminated and viewed. The former is numerically defined by its spectral power distribution as discussed above. A set of numbers defining the spectral power distribution of a light source is termed illuminant. The CIE has defined four standard illuminants. Of general interest are the two illustrated in Figure 6-11, daylight D6500 and tungsten light A, the former referring to an average daylight, the latter to the average light of a tungsten coil lightbulb. There is no real light source in existence that

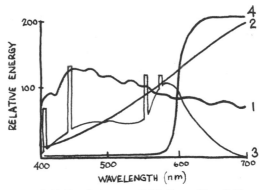

6-11. Spectral power distributions of four light sources: 1) CIE standard daylight D6500, 2) CIE tungsten light A, 3) "cool white" fluorescent, and 4) a "red" traffic light.

exactly matches Illuminant D6500. Illuminant A, on the other hand, can be reproduced relatively easily. Data of relative spectral power distributions of other light sources are available but they have not as yet been made official by the CIE.

Reflectance characteristics of objects are numerically expressed by their reflectance factor data. Reflectance factor is defined as the ratio of the radiant flux (light) reflected in a given direction to that reflected in the same direction by an identically illuminated perfect diffuser.[11] The latter is a non-existing hypothetical material having no absorption characteristics: it reflects all energy (light) by which it is struck across the visible spectrum. The light is not reflected in a particular direction by the perfect diffuser but rather diffusely in all directions (see Chapter 4). There are materials coming close in behavior to the perfect diffuser, such as the surface of a compressed layer of pure barium sulfate, a "white" powder. This and other materials are being used as reflectance standards. Their absolute reflectance characteristics

6-12. Schematic simplified representation of a spectrophotometer with an integrating sphere.

can be determined so that the result of the reflectance-factor measurement of materials can be expressed in terms of the theoretical perfect diffuser, even though it is measured with the help of a real standard.

The instrument used for the determination of reflectance factor is the reflectance spectrophotometer. A schematical view of a spectrophotometer in the version generally used for the determination of reflectance characteristics of many types of materials is illustrated in Figure 6-12. The "white" standard and the material for which the reflectance is to be measured are attached to an integrating sphere. This sphere allows the determination of diffuse reflectance characteristics, or the average light reflected in all directions. This is of particular importance for obtaining repeatable results for materials without smooth surfaces, such as textiles. Standard and sample (in the form of reflecting materials) are illuminated indirectly with the full spectrum of the light from a suitable light source such as a xenon or tungsten lamp. For the measurement of most materials (all those being nonfluorescent) the quality of light used has no effect on the results of the measurement, since the ratio of incoming and reflected light is determined (the former measured on the white standard, the latter on the sample). A sufficient quantity of light at each wavelength to result in an accurately measurable response is required, however. Light reflected from the "white" standard and the sample is passed through a monochromator (a prism or a grating), and the quantities of the emerging light are measured continuously or at given intervals throughout the visible spectrum with the help of a light-sensitive cell or a photomultiplier tube. The reflectance factor is the ratio of the measured values for the standard and the sample at a given wavelength (after suitable correction so that the result is expressed relative to the perfect diffuser). With modern instruments, complete reflectance spectra for the visible region can be determined in five seconds or less. Typical examples of reflectance spectra for three objects are illustrated in Figure 6-13.

With separate data on the spectral power distribution of the light source and the spectral reflectance factor of the object, the calculation of the CIE tristimulus values X, Y, and Z for the related colors proceeds as

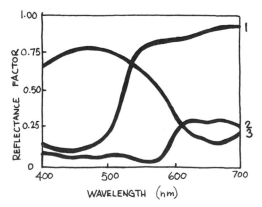

6-13. Reflectance characteristics of three materials: 1) lemon, 2) "brown" leather, and 3) "blue" paint.

schematically illustrated in Figure 6-14. In practice the calculation, usually done by a computer connected to the reflectance spectrophotometer, is simplified by the use of (published) so-called weights, the pre-calculated products of the spectral power distribution of the light source (illuminant) and the spectral color matching functions. These weights are multiplied by the corresponding reflectance factor values and the products totaled to give the tristimulus values. Note that the nature of the light source used for the determination of reflectance factor has no bearing (for nonfluorescent objects) on the tristimulus values. These are solely based on the illuminant data used in the calculation. The tristimulus values for nonfluorescent materials can maximally be those of the light source. This applies for the perfect reflecting material. All real materials, absorbing some of the incident light, will have tristimulus values lower than those of the light source.

With the determination of the tristimulus values for nonrelated and related colors we have attained, if in a limited way, our goal of quantifying the stimulus. The limitations are quite severe, however. The three tristimulus values uniquely represent the color sensation obtained by the standard observer (one with color matching functions as exemplified by Figure 6-9) when viewing under standard conditions in a standard surround a stimulus represented by its spectral power distribution (or the product of the light source power distribution and object reflectance factor). If observer, light source, or reflection changes, the tristimulus values and generally the color sensation change. If surround and viewing conditions change, the tristimulus values remain the same but the sensations change. Therefore, it is often not evident from the tristimulus values what the corresponding sensation is.

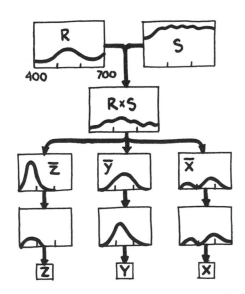

6-14. Schematic representation of the determination of the tristimulus values X,Y,Z for a reflecting object of reflectance factor R, viewed in the light of spectral power distribution S, by the standard observer represented by the color matching functions \bar{x}, \bar{y}, and \bar{z}.

There is merely the certainty that, if viewed under comparable conditions, two stimuli resulting in identical tristimulus values will be seen as matching.

The sensations caused by pure spectral lights form the limits of color sensation in respect to saturation. All related colors, because of a certain amount of light absorption by the reflecting material, have a reduced chromaticness. The vectors in the geometrical space formed by the tristimulus coordinates X, Y, and Z (comparable to the red, green, blue space of Figure 6-2) of colors caused by spectral lights therefore form a boundary surface of real color sensations of maximum saturation. This surface is schematically illustrated in Figure 6-15.[12] The dashed line closing the spectral surface represents vectors obtained by mixing the stimuli at 400nm and 700nm in various proportions. These mixes are perceived as various shades of purple, and the connecting line is called the purple line.

The plane in which the spectral vectors are shown to end can be used for qualitative and in some ways quantitative identification of color sensations (subject to the earlier mentioned limitations). All real color sensations have associated tristimulus values making them fall on or within the horseshoe-shaped outline in Figure 6-15 and each color sensation is represented in this plane as a point. The coordinate system for the plane is based on so-called chromaticity coordinates. These are calculated in a simple way by dividing each of the tristimulus values by the sum of all three tristimulus values. The resulting chromaticity coordinates are designated x, y, and z, where x is the result of dividing the tristimulus value X by the sum of the tristimulus values X, Y and Z; y and z are calculated accordingly. In the CIE standard colorimetric system, x and y are used as the rectangular coordi-

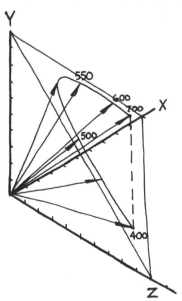

6-15. Schematic depiction of the vector space with axes represented by the nonreal primary light sources X,Y, and Z. The end points of vectors of spectral lights (curved line with identification of selected wavelengths) are located on the plane connecting the maximum values of the three imaginary light sources.

nates for the chromaticity diagram, illustrated in Figure 6-16. This diagram maintains additive color mixture properties inherent in the CIE system, those mixtures in various ratios of two stimuli anywhere in the diagram that fall on the straight line connecting the two stimuli. Point E is the neutral point of the system. It designates a white color based on a light source of spectral power distribution of unity across the spectrum and on the perfect diffuser (one hundred percent reflectance across the spectrum). The positions of the colors caused by CIE standard illuminants D6500 (daylight) and A (tungsten light) are also indicated. They illustrate that the system does not in any

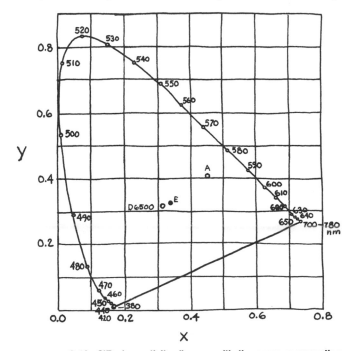

6-16. CIE chromaticity diagram with the curve representing chromaticities of spectral lights, the purple line, the neutral point E, and the location of light sources D6500 and A.

way account for adaptation. All sensations are represented in terms of "neutral" adaptation to a light source having unit power across the spectrum (represented by E). Since E represents the achromatic color of the system and the horseshoe-shaped outline the spectral colors, increases in saturation are represented by increases in the distance away from E up to the maximum saturation (that of spectral colors). Hue changes in a circular fashion around the neutral point E. It is customary for related colors to regard the position of the light source in the diagram, in case of usage of light sources other than E, as the achromatic or neutral point. As an approximate correlate of perceived hue the so-called dominant wavelength is occasionally used. If in the CIE chromaticity diagram a straight line is drawn from the point representing the light source through the point representing the color in question and intersecting the line of spectral colors, the dominant wavelength is that of the intersection point. If the line drawn intersects the

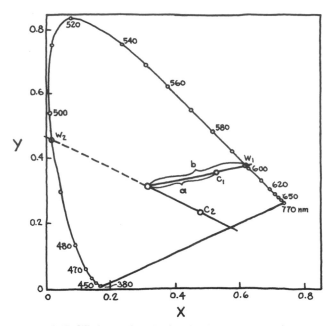

6-17. CIE chromaticity diagram illustrating the determination of dominant or complementary wavelength and of purity. W_1 represents the dominant wavelength of color C_1, W_2 represents the complementary wavelength of color C_2; a and b are the distances from which purity is calculated.

purple line in the diagram, the complimentary dominant wavelength is found by extending the line backward until it intersects the line of spectral colors, as illustrated in Figure 6-17. This figure also depicts the basis for calculating an approximate correlate of saturation, the purity. Purity is calculated as the ratio of the distance between the point representing the light source and the point representing the color on the one hand and the distance between the light source point and the point of intersection on the spectral or purple line on the other hand. These are measures that can be calculated from colorimetric data.[13] But as we will see in the next chapter, they do not stand in a simple relationship to perceived colors.

The diagram does not contain any information about lightness or brightness. We recall, however, that one of the conditions of the CIE for selection of the X, Y, and Z transformation is identity of the \bar{y} color matching function with the photopic luminosity function Vλ. The tristimulus value Y, therefore, provides information about the luminosity of unrelated colors and the luminous reflectance of related colors. Complete and equivalent specifications of colors in the CIE system can be expressed by the values X, Y, and Z or the values x,y, and Y. One set of values can easily be calculated from the other. The latter form is generally preferred, as it is based on the chromaticity diagram. It should be stressed again that most colorimetric colors X, Y, and Z or x, y, and Y (except for the spectral colors) can be caused by a multitude of spectral power distributions having identical effects on the visual system and causing, when viewed under identical conditions, the same sensation.

With the specification x,y,Y, we are back in a three-dimensional system, but one based on the chromaticity diagram. Just as the spectral and purple outline indicates the border of possible sensations in terms of hue and saturation, there must be such a border for related colors in terms of lightness also. This border is illustrated in Figure 6-18 for objects seen in daylight. No real related color (caused by nonfluorescent samples) exists outside the enclosure illustrated in Figure 6-18. The colors on the envelope itself are based on nonexistent idealized colorants and the color sensations caused by real objects when viewed by the standard observer in daylight fill only a portion of the space enclosed by the envelope. An envelope of different shape is formed in the CIE system by colors based on objects seen in the light of a different source, such as tungsten light.

A peculiarity of the CIE colorimetric system discussed above is that no position can be assigned in the chromaticity diagram to a perfect black, a black caused by viewing an object having zero reflectance. The corresponding tristimulus values X, Y, and Z as well as the chromaticity coordinates turn out to be zero, with the ideal black having no position within the outline of real colors.

It has been mentioned earlier that the tristimulus values for colors caused by materials are determined from measurements of reflection or transmission (the latter for transparent objects) and usually calculated with the help of a computer. There is also a type of instrument, called a colorimeter, allowing the direct determination of tristimulus values. Instead of a monochromator breaking the reflected (or transmitted) light into its spectral components, in these instruments light is passed through filters having transmission characteristics imitating the CIE color matching functions. In this way the response of the light-sensitive sensor of the instrument mimics that of the visual receptors (as represented by the CIE color-matching functions). The accuracy of such instruments is limited because of technical difficulties in

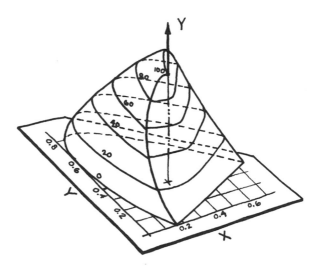

6-18. Oblique view of the CIE chromaticity diagram and the surface of optimal related colors for daylight illumination.

preparing suitable filters. Until recently, the instruments had a distinct advantage in measuring time compared to spectrophotometers, but this advantage has been eliminated. Lower cost (for less information produced) is today the only advantage of colorimeter over spectrophotometer.

In this chapter we have encountered a system used internationally for quantifying the color stimulus, the CIE colorimetric system. The CIE standards cover relative spectral power distributions of light sources, the illuminants, the quantification of the reflection or transmission properties of objects (various measuring techniques are standardized) and the color matching functions of the standard observer. The result is the numerical definition of a color sensation in terms of three tristimulus values. The only truly valid use of tristimulus values, however, is the determination of equality or inequality of the sensations resulting from two visual stimuli. In other words, with this system we can only properly determine if two stimuli result in matching sensations or not. Today in color science and technology the system is used for many other applications, uses that often exceed by far the original intent. It is not surprising, then, that the system is occasionally found to be lacking, not because it fails in its original purpose but because it is used for purposes for which it cannot provide adequate information. It has nevertheless been, and remains to be, highly successful in color technology.

Determinations of spectral power distributions of light sources and of reflection/transmission characteristics of materials are strictly physical measurements. The color matching functions are based on carefully determined experimental data. The system is technically sound. However, the standards selected by the CIE represent only very limited and specific situations while our daily color experiences represent a myriad of nonstandardized situations. It is not surprising, then, that colorimetry and visual experience are on occasion not in agreement. The following chapter concerns itself with the relationship between the CIE colorimetric system and color sensation, as well as the appearance of colored objects.

Footnotes

1. *Vector,* is from the Latin *vehere, to carry.* A vector is a quantity having magnitude and direction, normally represented by a line whose length represents the magnitude and whose orientation in space represents the direction.

2. This law was first postulated by the German mathematician, physicist, and Sanskrit scholar Hermann Günter Grassmann (1809-1877); see Grassmann, H.G., "Zur Theorie der Farbenmischung," *Poggendorfs Annalen der Physik* 89 (1853), pp.69-84: as translated in MacAdam, D.L., *Sources of Color Science,* op.cit. The law has been expressed in many ways.

3. It is difficult to categorize color-normal observers, since sensations are private. A small but significant percentage of people (approximately twelve percent) have color vision demonstrably and significantly different from the rest. They are not able to distinguish as many color sensations (on the basis of the same stimuli) as the rest of the population. Color-normal observers are those not having these deficiencies. Among observers classed on the basis of certain visual tests as color-normal, there can still be substantial differences in color vision. This is demonstrated, for example, in their personal color-matching functions, which lead to sometimes subtle and at other times significant differences in sensations. For extensive discussions of color vision deficiencies see Boynton, R.M., *Human Color Vision,* op.cit., and Hurvich, L.M., *Color Vision,* op.cit.

4. The designation *tristimulus* indicates the triadic nature of color sensation, presumably due to the existence of three independent receptors involved in color vision. The illustrated curves

represent an average of some fifty observers, each individual having his or her own specific tristimulus value curves.

5. The calculation method discussed is abbreviated, but is accepted by the CIE. The exact calculation method, rarely used, involves integration.

6. *Colorimetry* (from *color*, Latin, meaning *color*; and *metrein*, Greek, meaning *to measure*) is the term used to denote a system of color definition and specification based on three numbers, the tristimulus values.

7. *Scotopic* is from the Greek *skotos*, meaning *dark*, and *opsis*, meaning appearance; it refers to vision in dim light.
Photopic, is from the Greek *phos*, meaning *light*, and *opsis*; it refers to vision in normal light.

8. The photopic response function, the first function to be standardized by the CIE (in 1924) has remained somewhat controversial because its exact shape depends on the experimental conditions used in its determination. Long-discussed revisions have not been agreed upon as yet, however.
 The writer is aware that the transformation chosen for the experimental color-matching functions depicted in Figure 6-4 does not result in an exact duplication of the brightness function Vλ. This is a complication that does not concern us here.
 Brightness is a psychological concept; the term chosen for the psychophysical function Vλ is photopic luminosity function (from *lumen*, Latin, meaning *light*). The psychophysical correlate of brightness is called luminosity; in regard to lightness, it is called luminous reflectance.

9. These are pronounced *ex-bar, why-bar,* and *zee-bar.* Tabulations of these functions at 1nm intervals and to six significant figures are found in Wyszecki, G. and Stiles, W.S., *Color Science,* second edition, New York: John Wiley & Sons, 1982, and in other standard works on colorimetry.

10. We have encountered the term *tristimulus value* before (see Footnote 4). Here it designates one of the three sums calculated as discussed. The three tristimulus values X, Y, and Z represent the psychophysical definition of a color.

11. The exact definition of reflectance factor is more specific and complex but does not concern us here.

12. The description presented here is knowingly simplified. In reality, the system is more complex but the complete details have been omitted for the sake of clarity. For a complete discussion consult a standard text such as Judd, D.B. and Wyszecki, G., *Color in Business, Science, and Industry,* op.cit.; Wyszecki, G. and Stiles, W.S., *Color Science,* op.cit.; or Wright, W.D., *The Measurement of Colour,* fourth edition, New York, New York: Van Nostrand Reinhold Company, 1969.

13. In colorimetry a distinction is made between "excitation purity" and "colorimetric purity." Figure 6-17 illustrates the determination of the former. For a detailed description of determining CIE dominant wavelength and purity see e.g. Judd, D.B. and Wyszecki, G., *Color in Business, Science, and Industry,* op.cit.

7

**Orderly Arrangements of
Colors, Revisited**

In the previous chapter we encountered the CIE colorimetric system making possible, in a limited way, the numerical quantification of color. It is of interest to look at the problem of orderly arrangements of colors again in the context of the CIE system, as this allows us to describe such an orderly arrangement in terms of tristimulus values and chromaticity coordinates. It is of immediate interest to see what plots of orderly arranged colors look like in CIE color space. The orderly arrangement of color sensations most suitable for such a comparison is perhaps the Munsell Color System because of its inherent attributes hue, chroma, and lightness (value). By using this system we assume, for example, that the color chips of the system can represent the respective sensations and that the Munsell system attributes are perceptually uniformly spaced. As a first approximation these assumptions are quite certainly valid. A plot of lines of equal hue and equal chroma at a given level of lightness is illustrated in the CIE chromaticity diagram in Figure 7-1. In most cases sensations having the same hue but differing in chroma are represented by curved lines. Sensations of equal chroma are not represented by circles in the chromaticity diagram, but by approximately egg-shaped ovals. Lines representing color sensations of chroma 2 at various levels of lightness are illustrated in Figure 7-2. These indicate a funnel-shaped surface of colors of equal chroma in CIE x,y,Y space. It is evident

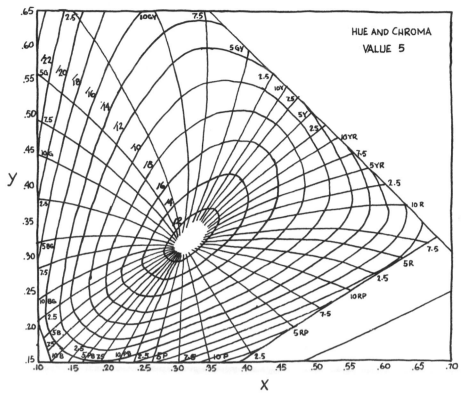

7-1. A portion of the CIE chromaticity diagram with lines of equal hue (radial) and of equal chroma (oval) at Munsell value 5. Major Munsell hues are identified as well as certain levels of chroma.

that colors of equal purity (see Chapter 6) but differing in luminance or luminous reflectance do not have equal chroma. To some extent this is an inherent nonuniformity of CIE space (in terms of perceived chroma) and to some extent it is due to the simultaneous contrast effect (see Chapter 4) of the medium-lightness gray used as a surround in evaluating chroma scales in the Munsell system. Different shapes of the funnel would have been obtained had lighter or darker surrounds been used in the determination of the Munsell chroma scales.

Lines in the chromaticity diagram representing colors of equal hue but varying in chroma are, as seen in Figure 7-1, generally slightly curved: colors of equal dominant wavelength but differing in purity are usually not seen as having the same hue. The position of lines of equal hue in the chromaticity diagram also depends on the lightness (value) of the colors, as illustrated in Figure 7-3 for Munsell colors 10R and 5P for value levels from 2 to 8. A given point in the chromaticity diagram therefore usually does not indicate colors of identical hue regardless of lightness. This is particularly evident in the case of color 10R. The reason is a visual phenomenon called the Bezold-Brücke effect,[1] according to which the perceived hue of most lights varies to a smaller or larger degree depending on the brightness (correspondingly for related colors). The effect is best illustrated with spectral lights, the per-

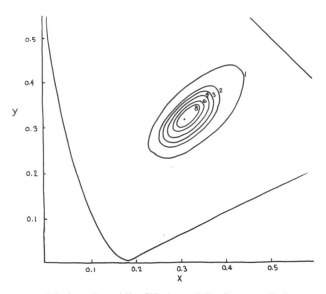

7-2. A portion of the CIE chromaticity diagram with lines of colors of chroma 2 at value levels from 1 to 8.

ceived hue of which varies in many cases distinctly with the brightness of the light.

The relationship between luminous reflectance and Munsell value (or lightness) is illustrated in Figure 7-4.[2] It is clearly not a directly proportional

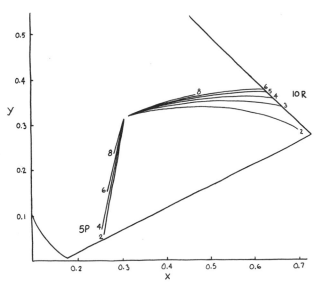

7-3. A portion of the CIE chromaticity diagram with lines of constant hue of two Munsell hues (10R and 5P) at various levels of value.

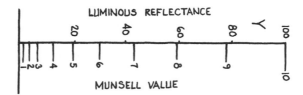

7-4. Munsell value steps and their relationship to luminous reflectance (Y).

relationship but rather is quite well approximated by a cube-root relationship, which says that lightness increases approximately as the cube-root of luminous reflectance. However, the particular relationship illustrated is valid only for a light gray surround and would be different for a white or dark surround.

Our discussion and the figures so far have indicated that the relationship between perceived color and psychophysical color (tristimulus values) is quite complex. Very similar results are also obtained when plotting OSA Uniform Color Scales colors in CIE color space even though the complexities of relationship are not as easily apparent. Figure 7-5 illustrates the position of colors selected to represent the Uniform Color Scales, having lightness

7-5. CIE chromaticity diagram illustrating OSA-UCS color chips at lightness L=0.

L=0 (Y=30), in the chromaticity diagram. Lines connecting colors of four hues, the basic hues of the system, are indicated, illustrating again the curvature in the diagram of lines of equal perceived hue. It should be recalled that the points illustrated represent colors perceived to be equally (or nearly equally) distant from the nearest neighbors. It becomes apparent that equal perceived color differences are not represented by equal distances in the chromaticity diagram. This is not surprising, as the basic purpose of the CIE colorimetric system is to determine if two unlike spectral power distributions result in matching sensations. The implied ability of quantifying color sensations in the colorimetric system[3] and the relative ease of determining tristimulus values has made the temptation to use colorimetric data for the prediction of sensations and their relationships irresistible. Such prediction is simplified by converting the CIE x,y,Y color space (see Figure 6-18) into a transformed space more uniform in terms of sensations. Perceptual data like those of the Munsell system and the OSA-UCS system have been used to arrive at such transformed spaces.

There are no unequivocal rules and guidelines to be used in the development of the necessary mathematical transformation equations, although many proposals have been made. The CIE has changed its relevant recommendations over the years, and the latest one is considered temporary.[4] Basically, there are two possible approaches: one is to develop empirical direct mathematical relationships between colorimetric data and visual scale data; the other is to mathematically model the presumed workings of the color vision sense and to optimize the model with the use of visual scale data. The latter method is perhaps the more meaningful one. Typically, the tristimulus values are linearly transformed into a system believed to represent primary cone responses (such as those of Figure 6-5) or they are themselves used as primary response data. They are then rescaled to duplicate the nonlinear relationship between stimulus and sensation, an example of which is shown in Figure 7-4. The response compression illustrated in this figure is the result of a form of adaptation. Figure 7-6 illustrates the relationship between stimulus and sensation according to Fechner's law.[5] The arith-

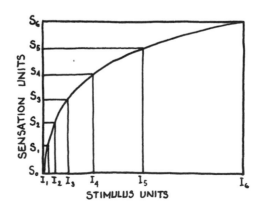

7-6. The general relationship between stimulus and sensation according to Fechner's law.

7-7. Plane in CIELAB L*,a*,b* space at L*=50 containing plotted points of the Munsell colors of value 5.

metic scale of stimulation corresponds to a geometric scale of sensation. Fechner's law was found to have limited validity in color scales, however, and a power relationship (such as a cube-root relationship) is generally found to be a better numerical approximation. After such rescaling of the stimulus, mathematical correlates of opponent-color signals are calculated in the form of differences between the contracted cone outputs.

As mentioned in Chapter 3, several proposals for cone-output relationships have been made leading to a corresponding number of possible mathematical relationships. Our discussion follows the CIE recommendation of the CIELAB color space.[6] For the red-green signal a*, the cube-root of the tristimulus value Y is subtracted from that of X and the difference is multiplied with a factor. A positive difference indicates a red signal, a negative difference a green signal. Similarly, the yellow-blue signal b* is calculated as the difference between the cube root of the tristimulus value Y and that of Z (multiplied by a factor). The result can be represented geometrically in a two-dimensional rectangular coordinate system. The lightness value L* is calculated as the cube-root of the tristimulus value Y, multiplied with a factor, and forms the third dimension in the coordinate system. Figure 7-7 represents a plane in this coordinate system at L*=50, containing plotted points of the Munsell colors of value 5. From a comparison of this figure with Figure 7-1 it is apparent that, as intended, in the former the Munsell samples are much more evenly (if not perfectly) spaced than in the latter. The color space presented here is the CIE 1976 L*a*b* (or CIELAB) uniform color space. Figure 7-8 illustrates the envelope of optimal colors for daylight illumination in this space. It is comparable to that shown in Figure 6-18 in the CIE x,y,Y space except that, unlike in the latter, in the former equal perceptual differences are represented by approximately equal geometrical distances.

Another CIE-recommended uniform color space is the CIE 1976 L*u*v* (or CIELUV) space. The lightness dimension L* is the same as in the CIELAB space. The chromatic dimensions u* and v* are calculated on the basis of a relatively simple linear transformation from the chromaticity coordinates x and y. The u*, v* diagram is also more uniform in terms of perceived differences. At the same time it maintains the additive relationships for nonrelated colors that the chromaticity diagram embodies. The colors caused by mixing two lights in various ratios plot on a straight line in this

diagram, as in the chromaticity diagram. Both spaces, CIELAB and CIELUV, are said to be uniform because they are believed to be better geometrical correlates of perceptual color scales, based on equality of intervals, than the x,y,Y space. But available evidence indicates that both must be regarded as approximations. CIELAB space, for example, represents simplified findings based on Munsell data. But no attempt has been made to make the space

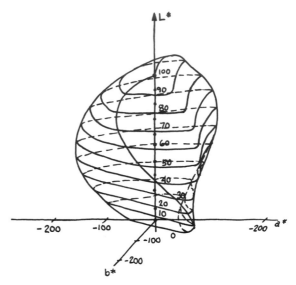

7-8. CIELAB space with envelope of optimal colors for daylight illumination.

represented by the formula fit the data closely. It should predict equal visual spacing of color sensations reasonably well if color chips, surround, and viewing conditions are comparable to those used in establishing the Munsell system. If these conditions are changed (for example if the chips are presented differently), the capability of the formula to accurately predict the sensations is reduced.

Color Differences

The color difference between two colors is calculated, in CIELAB space for example, as the square root of the sum of the squares of the differences in L*, a* and b* values of the two colors. In Figure 7-9a, the contours representing colors the formula predicts to be visually equally different from the color represented in the center of the contour are illustrated for twenty-nine

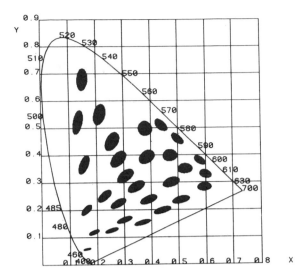

7-9a. CIE chromaticity diagram with contours of unit color difference (from the color in the center of the contours), contours 10 times enlarged, Y=40, CIELAB color difference formula.

colors in the chromaticity diagram.[7] If illustrated in the a^*, b^* diagram, these contours would be circles of equal size. Figure 7-9b illustrates that the CIELUV formula, on the other hand, predicts considerably different contours. When either of these sets of contours are compared against some that have been determined by direct visual evaluation of color differences, the correlation is found to be quite poor. However, various sets of published data about visually evaluated color differences are not in close agreement with each other either. There appears to be a considerable number of experi-

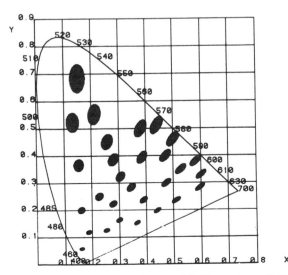

7-9b. Identical as Fig. 7-9a except that the contours illustrated are those resulting from application of the CIELUV formula.

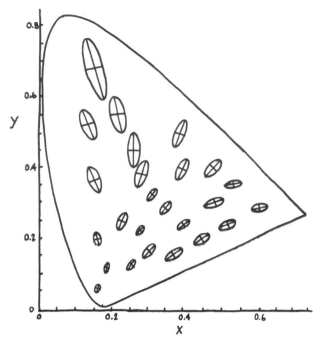

7-10. CIE chromaticity diagram with standard deviation ellipses (ten times enlarged) of the error of color matching of twenty-five colors (located in the center of each ellipse).

mental factors that can lead to differences in the results. A well-known example of visual data is illustrated in Figure 7-10.[8]

These ellipses are believed to represent the threshold of color difference, i.e. if the test color falls within the ellipse around the standard color in the center, a typical observer will judge the two sensations to be identical. If the test color falls on or outside the ellipse the two sensations are seen as different. However, these ellipses have not actually been determined by color-difference evaluation. Instead they represent the statistical standard error of color matching of one observer. The observer involved has repeatedly attempted to match the color caused by lights represented by the center of the ellipse by adjustment of light intensities. The ellipses were calculated on a statistical-mathematical basis from data representing the errors made by the observers in these attempts at matching. Twenty-five of the twenty-nine colors in Figures 7-9a and 7-9b are identical to those in Figure 7-10, which facilitates comparison.

A different set of ellipses is illustrated in Figure 7-11. These are based on average visual estimates of the differences in sensation caused by two colored samples touching on one edge when viewed under certain standard conditions of illumination and surround. The chosen conditions are somewhat representative of the practice of industrial color-difference evaluation in colorant producing and using industries. The results appear to be different again. The problem that becomes apparent is that there is a lack of sufficient experimental data to draw conclusions regarding the influence of certain experimental parameters on the total result of color difference evalua-

tion. Until a sufficient amount of such data is available arguments about the merits of the many color-difference formulas will continue.

We have seen that computed color differences in CIELAB space involve three components: a redness-greenness component, a yellowness-blueness component, and a lightness component. This choice of components conforms to an opponent-color system. By simple mathematical manipulation it is also possible to express a given color difference in terms of Munsell-like attributes: hue difference, chroma difference, and lightness difference. Either system can offer significant insight into the nature of the total color difference.

Tests have established a considerable variability in color-normal individuals in terms of color-difference judgments, not only from one individual to the next but also within the same individual as a function of time. Visual color-difference evaluations of single individuals are therefore relatively unreliable. It is easy to understand that industrial manufacturers of colorants and colored goods have been looking for an objective method to determine color differences. In a sense this has been accomplished. The excellent

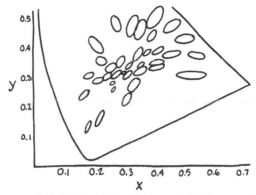

7-11. Portion of the CIE chromaticity diagram with unit color difference ellipses (ten times enlarged) based on average visual evaluations of sample pairs.

measuring repeatability of modern instruments will unhesitatingly produce near-identical data on repeat measurements of a given set of samples. In this sense objectivity has been attained, an objectivity that is very valuable. But when the instrumentally determined color differences for a set of samples are compared to those representing the average (repeatable) visual judgment of a group of observers, obtained in a particular set of conditions, it becomes evident (see Figure 7-12) that much is left to be desired. It can be seen in this figure that, for example, color sensations caused by sample pairs judged visually to have a difference of two units are by instrumental measurement and computation evaluated as having CIELAB differences of anywhere from one to eight units. Similar results are obtained with other color-difference formulas. The formula evidently predicts the general trend of the visual evaluations reasonably well but misses many details. As a whole, accurate, objective color-difference evaluation is a goal that has escaped realization up to now.

We have seen that colorimetry itself offers a model for the orderly

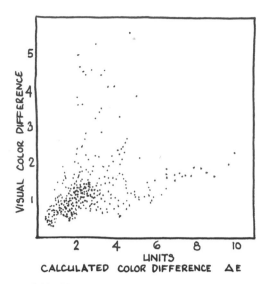

7-12. Diagram illustrating the correlation between average visually evaluated color differences between 536 sample pairs and the corresponding calculated CIELAB color differences based on reflectance-factor measurements of the samples.

arrangement of colors. In the x,y,Y color space we find all color sensations (keeping in mind certain conditions and restrictions) arranged in an orderly fashion. Furthermore, the detail of refinement of the arrangement is almost unlimited. But the system lacks uniformity in the perceptual sense. Various proposals for systems derived from the basic colorimetric system but leading to results that are in better agreement with average visual judgments, such as the CIELAB and CIELUV systems, have been made. While offering improvement, they nevertheless continue to leave much room for further developments.

Footnotes

1. The Bezold-Brücke effect is a sensory effect, named after two German scientists, according to which the hue sensation caused by light of all but three wavelengths changes with increasing intensity.

2. In the Munsell system, samples of equal value all have identical luminous reflectance values (Y). Experiments have indicated, however, that, in particular for unrelated colors of high saturation, constant brightness is not equivalent to constant luminosity. Spectral lights of a given Y value and high saturation cause sensations of higher brightness than lights producing sensations of identical hue but lower saturation. The increase in perceived brightness depends on the hue of the color.

3. The ability is presumed because colorimetric data are valid only for sharply defined standard conditions usually not met in practical situations and are implicitly restricted to the question of the existence of a match. Direct quantification of color sensations such as that used in the Natural Color System, while useful for many purposes, is not precise enough for most technical applications.

4. The development of better-founded recommendations is hampered by an unfortunate lack of experimental data.

5. Fechner's law was proposed by the German physicist-philosopher Gustav Theodor Fechner (1801-1887), the founder of psychophysics, the study of the relationship between stimulus and response.

6. The CIELAB color space is one of two spaces tentatively recommended by the CIE in 1976 (Robertson 1977) for the purpose of uniformity of usage and pending a better understanding of the relationship between stimulus (in the form of tristimulus values) and color sensation. The other recommended space is the CIELUV space. Note that the term *color space* is used both for the geometrical model of a logical arrangement of color sensations and for its mathematical correlate.

7. The complete contours are, of course, three-dimensional and should be illustrated in x,y,Y space. For reasons of clarity the Y-dimension has been omitted. The particular colors illustrated have been chosen for technical reasons. Comparable contours can be calculated for any other color in the diagram.

8. The illustrated ellipses are the so-called MacAdam ellipses (see for example MacAdam, D.L., *Color Measurement: Theme and Variations*, New York, New York: Springer Verlag, 1981).

8

Colorants and Their Mixtures

Colorants are materials having absorbing and/or scattering properties in respect to light. Light striking them is being changed spectrally and/or in intensity, and may now give cause to color sensations. We have seen in Chapter 3 that the light-absorbing properties are due to the behavior of certain electrons in the colorant molecules. There are two types of colorants: pigments that absorb and scatter visible energy and dyes that essentially only absorb it. The distinction between dye and pigment is not all that clear. Some chemical substances can exist as dye or as pigment. Dyes are those colorants which, at one time during the application process, are dissolved in the application medium. Thus, disperse dyes (used for dyeing of polyester fiber), even though they are poorly soluble in water, are in fact dissolved in the water of the dyebath before entering the polyester fiber and being "dissolved" by the fiber material. Pigments, on the other hand, are finely ground (and therefore also scattering) absorbing materials that are mixed with a vehicle with adhesive properties, a material which, on drying, forms a transparent film.[1] This film holds the particles in place and normally affects their absorbing and scattering properties only to a small degree.

Dyes, having absorbing properties only (with few exceptions), can be used to color transparent materials such as films, liquids, plastics, and so forth. They are also used, for technical reasons, to color translucent objects,

in particular textiles and paper, and to impart a surface coloration on opaque objects without affecting the surface structure of the material, such as in the case of dyed leather or stained wood. Opaque objects are generally colored with pigments, usually in the form of paints.

Whether a colorant does or does not scatter light depends on the size of its particles relative to the wavelengths of light. If the particles are very small, perhaps single molecules, the light will not be scattered but will either be absorbed or pass by the particles unaffected. If the particles are relatively large, say 0.1 to 10 microns in diameter, caused for example by crystal formation of the colorant molecules, scattering will occur.[2] There is an optimum particle size resulting in the highest degree of scattering possible. Scattering is often a desirable property: it is used to obtain hiding (concealment) of the surface of the material to which the scattering colorant has been applied or to make transparent or translucent materials opaque. A practical example is a "one coat" paint, a paint covering the surface to which it is applied with an opaque layer in just one coating.

If we dissolve a small amount of a nonscattering colorant in a suitable transparent substrate, say, a "red" dye in water, we obtain a lightly colored solution. The color sensation perceived depends on the colorant, its concentration, the light source used to view the solution and the background and surround. An increase in dye concentration results (up to a certain point) in an increased chromaticness of the sensation. The immediate effect of the dye is to decrease the transmission of light through the transparent substrate (the water in which the dye was dissolved) by the process of absorption. This effect can be measured by a spectral comparison of the transmission properties of the solvent containing the dye to those of the solvent alone. The difference can be seen as representing absorption by the dye. Depending on the nature of the dye, the absorption can be located in one or another area of the spectrum. It can be in a relatively narrow band or in a broad band of the spectrum. Absorbance curves of typical dyes absorbing in a narrow band and in a broad band are illustrated in Figure 8-1. Such curves tend to be quite specific for given colorants and can be used as "fingerprints" for identification.[3] The definition of absorption in relation to (as a function of) transmission has been chosen in such a way that normally dye concentration and measured absorption are proportional. This is particularly useful for the determination of the unknown concentration of a given dye in solution. The derived value, absorbance, is directly displayed or plotted on modern spectrophotometers. It ranges from 0 at one hundred percent transmittance to 3.0 at one tenth percent transmittance. If a dye solution at forty-milligrams-per-liter concentration results in an absorbance value of 0.5, it will normally have an absorbance value of 1.0 at eighty milligrams per liter, measured under otherwise identical conditions.

Absorbances are additive. The absorbance of a mix of two dyes, each at a given concentration, can be calculated from the absorbance values of the individual dyes at their respective concentrations simply by adding the two absorbance values at each wavelength. Because of the proportionality of absorbance and dye concentration it is even possible to calculate the absorbance curve of a mix of dye A at, say, forty milligrams per liter and dye B at, say, seventeen milligrams per liter from known absorbance data of

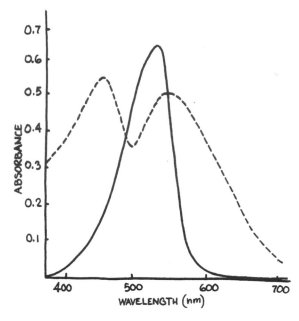

**8-1. Absorptance curves of a narrow-band absorbing (————)
and a wide-band abosrbing (- - - -) dye.**

each dye at, say, twenty-five milligrams per liter.[4] Up to now we have
assumed that all measurements have been made at equal thickness of
solution layer. Rules of proportionality also apply in the case of varying thick-
nesses of measured layer. If a given dye in a given concentration results in
an absorbance of five tenths of a unit when measured at a given wavelength
and a thickness of solution layer of one centimeter, a doubling of the layer to
two centimeters normally results in a doubling of the absorbance value to
one unit.[5]

A comparable situation applies in the case of opaque colorations
(such as pigments in paints or dyes in an opaque layer of textiles). The
instrumentally measured value in this case is the reflectance factor (see
Chapter 5), which describes the proportion of light being reflected from the
surface of an opaque material at a given wavelength. The reflected light is a
function of both the absorbing properties of the colorants and the scattering
properties, either of the colorants if they scatter light or of the substrate
material. Dyes generally only absorb light while pigments both scatter and
absorb light. The absorption and the scattering are usually spectrally depen-
dent; they are different at each wavelength. Examples of relative scattering
and absorption curves of an "orange" pigment are illustrated in Figure 8-2.
The scattering values are identified with the letter S, the absorption values
with the letter K. They are expressed relative to the scattering and absorp-
tion behaviour of a "white" standard pigment (usually titanium dioxide) for
which at each wavelength K and S are set to a value of 1.0. The reflectance
factor is related in a relatively simple manner to the ratio of K and S; K/S.[6]

Both K and S are (at least in theory, there are many practical difficulties) additive, so we can calculate the scattering and absorption properties of a mixture of pigments from a knowledge of the K and S values of the individual components in unit concentration. To determine the relative K and S values of a given scattering colorant is relatively complex, however, and involves the preparation of several colorations and the application of algebra (it is usually done today with the help of a computer).[7]

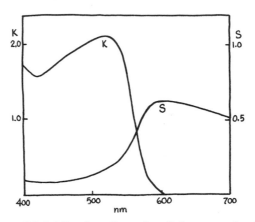

8-2. Relative absorption and scattering curves of an "orange" pigment (relative to titanium dioxide). The absorption curve is marked K, the scattering curve S.

In the case of dyes applied to textile materials, the situation is simplified in that the scattering effect is exclusively due to the textile material. It differs for various textile materials but for a given material it can be assumed to be constant and is assigned the value 1 at each wavelength. For this reason the K/S values for dyed textiles essentially are absorption constants only, since the scattering value is always at unity. In the case of dyes on textiles we have a rather straightforward situation, comparable to that of dyes in transparent media. If the Kubelka-Munk relationship applies (unfortunately there are often deviations in practice) reflectance data can be converted to K/S data, with the latter being proportional to dye concentration. In this manner it is possible to determine the unknown concentration of a given dye on a given textile material from reflectance measurements, the knowledge of the reflectance resulting from unit concentration of the dye on the substrate, and the application of the Kubelka-Munk relationship between reflectance and K/S. In the case of scattering colorants, because of the separate effects of scattering and absorption, the situation is somewhat more complex.

So far, we have considered purely physical aspects such as transmission, reflection, absorption, scattering, colorant concentration, and so forth. Our primary interest, however, is color. Let us prepare a series of dyeings of a "red" dye in increasing concentrations (usually expressed in percent of dye on the weight of textile material) from a very low concentration, perhaps one hundredth percent, to a high one, perhaps five percent, and look at these under standard viewing conditions. We will usually find that with

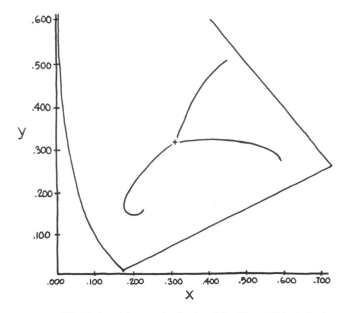

8-3a. Colorant traces of a "yellow," "red," and "blue" dye in the chromaticity diagram.

changing colorant concentration all three fundamental color attributes change: hue, chroma, and lightness. Lightness decreases steadily with increasing dye concentration. Chroma increases steadily, normally up to a point, and then may decrease with further concentration increases. Hue may change little or substantially but gradually, frequently changing first in one direction and then reversing. Dyes applied in varying concentrations on a substrate normally do not lead to color sensations that vary simply in regard to the fundamental color attributes. The changes can be expressed in terms of color order system coordinates on the basis of subjective judgments. More objectively, they can be expressed in terms of tristimulus values. These are determined for the standard observer and an illuminant in the usual way from measurements of reflectance factor of the dyeings. The result can be plotted in the CIE chromaticity diagram (neglecting lightness) or in the x,y,Y color space. Figures 8-3a and 8-3b illustrate representations of the colors caused by a series of dyeings of three dyes on a textile material.

The experimental data points have been connected to illustrate all intermediate dye concentrations. Such lines are often called colorant traces. Similar traces can be produced for pigments mixed in increasing concentrations with a "white" pigment base. Pigments are rarely used undiluted in paints but are generally mixed with a nonabsorbing, highly scattering base pigment such as titanium dioxide. This allows the preparation of paints hiding the surface of the material to which they are applied but resulting in color sensations of a wide range of hue, lightness, and chroma.

Certain pigments are quite transparent; light is not scattered efficiently by the surfaces of their particles but is transmitted through the crystalline structure of the particle. Such pigments, when applied by themselves in a binding vehicle of similar refractive properties, do not efficiently hide the

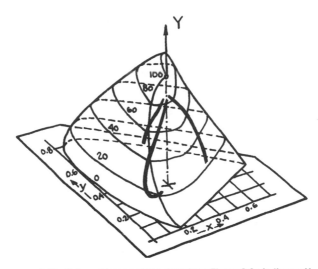

8-3b. Colorant traces of the dyes from Figure 8-3a in the x,y,Y color space.

background and the latter, white or colored, can be seen through the pigment layer. For some applications, this behavior is desired by artists. When mixed with an efficiently scattering "white" pigment base, the color and appearance caused by these pigments is often substantially different compared to that obtained when the pigments are seen undiluted in their masstone[8] over a "white" background.

The range of color sensations caused by a single colorant, applied in various concentrations to a substrate and viewed under a given set of conditions, is quite limited, as we have seen in Figure 8-3. Other sensations can be caused by mixtures of colorants. While absorption values of colorants are additive, the resulting color sensations are not. Colors caused by mixtures of colorants do, therefore, generally not plot on straight lines in the chromaticity diagram. The range of color sensations that can be produced by certain colorants and their mixture is called the gamut. The gamut is of considerable interest, especially in the case of technologies such as color photography, since it indicates the limit of sensations that can be produced with the particular colorants. In the case of photographic media there are only three colorants used, a "yellow," a "red," and a "blue" dye. An example of a color gamut of three textile dyes is shown in Figure 8-4. It is a specialized gamut, limited to dyeings containing in each case a total of two percent of dyes. The figure illustrates representations of the color sensations, plotted in the chromaticity diagram, caused by dyeings of a total concentration of two percent on weight of textile material of a "yellow," a "red," and a "blue" dye. In the case of dye mixtures the components are apportioned in simple, regular concentration intervals, such as in the row indicated by arrows in the figure. The concentration ratios (the concentrations always adding up to a total of two percent), starting on the left, are as follows: 7-0-3, 6-1-3, 5-2-3, 4-3-3, 3-4-3, 2-5-3, 1-6-3, 0-7-3. The first number refers to the concentration of the "blue" dye, the second number to that of the "red" dye, and the third number to that of the "yellow" dye.

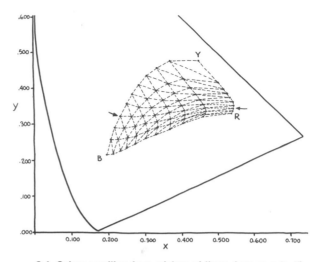

8-4. Colors resulting from mixture of three dyes on a textile material. The total dye concentration in each dyeing is two percent. The dye concentrations are varied in simple ratios (see text for more details).

Intermediate sensations could be obtained by proper adjustment of the ratios of the three dyes. It should be remembered that we have disregarded in our illustration the lightness component of the sensations. The lightnesses produced by the illustrated dyeings vary considerably; the illustration applies only to the three dyes involved. Other dyes generally result in different sensations, alone as well as in mixtures. But it may be possible to achieve identical sensations within overlapping areas of the gamut by proper adjustment of ratios. The figure provides us with an illustration of the complicated relationship between colorant concentration and resulting tristimulus values and sensations. It also suggests, however, the possibility of predicting the colorant concentrations necessary to produce a specific color sensation.

In Chapter 5 we encountered the laws of color stimulus mixture, the admixture of "colored" lights to produce new and different color stimuli. The most striking result of color stimulus mixture was, perhaps, that mixing a "green" light with a "red" light to produce a yellow sensation. This result is not only surprising in regard to hue but also in regard to brightness. It is not in agreement with our everyday experience, which is usually limited to colorant mixtures. The yellow sensation, brighter than either the red or green sensations, is possible because in color mixture the brightness of the sensation caused by the mixed light is at least the same and usually higher than that of the "brightest" of component lights. In this case stimuli are added to form a new combined, usually brighter stimulus. Additive primary stimuli resulting in the largest gamut of color sensations are "blue," "green," and "red".

In colorant mixture, a different situation obtains. Colorants (on textiles or in a paint) reduce the amount of light reflected from the substrate. If a small amount of a "black" pigment is added to a "white" paint vehicle, the resulting sensation is one of lower lightness. If a chromatic pigment is added

it results again in a reduced stimulus intensity, a hue sensation, and usually in a reduced lightness sensation. In colorant mixture the lightness of the related color sensation is at best the same but generally lower than that of the "lightest" of the component colorants. Adding colorant reduces the stimulus intensity until it approaches zero, with a resulting sensation of black. In color stimulus mixture, admixture of a "green" stimulus and a "violet" stimulus results in a bright greenish-blue sensation. Similarly, mixing of a "green" and a "violet" colorant results in a blue-hued sensation. However, because of the much reduced lightness, the sensation is one of navy blue. But the hue sensations resulting from color stimulus mixture and colorant mixture are only in some cases comparable. A mixture of approximately equal amounts of a spectral "blue" of wavelength 475nm and "yellow" of wavelength 575 nm results in a white sensation while a mixture of approximately equal amounts of dyes having the same dominant wavelengths will invariably result in a green sensation. The color sensations resulting from mixtures of color stimuli are relatively easily predicted with the use of the chromaticity diagram because of the linear relationships. The color sensations resulting from mixtures of colorants can also be predicted by calculation and illustrated in the chromaticity diagram, but it is a much more involved process because of the nonlinear relationships.[9] In order to obtain the largest gamut of color sensations, the colorants selected as primary must be "yellow," "red," and "blue." The critical colorant is the "yellow" one since it results in sensations of the highest lightness obtainable with a chromatic colorant. In order to produce a large mixture gamut, all three colorants should result in the lightest, highest chroma colors possible for the respective hues. However, this is of critical importance only for colorant applications relying on three (or four) colorants, such as color photography (or graphic printing). In most other colorant application techniques a considerable number of colorants is generally available with a resulting multiple choice of colorants that can be used to produce a given color sensation.

Figure 8-4 indicates a roughly circular arrangement of color sensations resulting from the mixture of three dyes, approaching the hue circles of some of the color order systems. Historically, artists and technicians have used color circles as aids to orient themselves in their colorant mixing activities, even though colorant mixture in simple ratios never leads to perceptually equidistant circles. It is necessary to distinguish between color circles as part of a color order system, usually representing color sensations of equal chroma with equidistant hue steps and colorant circles based on no other concept but that of convenience.

It is undoubtedly useful for artists and technicians to study the gamuts covered by admixture of certain colorants and compare them to those resulting from admixture of other colorants. Ideally, the results should be studied in terms of perceptually equidistant color order system, such as the Munsell or OSA-UCS systems, or, if a color measuring instrument is available, in terms of tristimulus values or CIELAB coordinates.

A special group of colorants, occasionally alluded to in earlier chapters, is that of fluorescent dyes and pigments. Fluorescent colorants are those that have the property of absorbing energy in the visible area of the spectrum, as all colorants do, but rather than re-emitting the energy in the

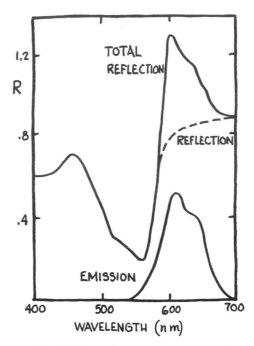

8-5. Reflection and emission curves and total reflectance of a fluorescent "red" dye applied to a textile material.

infrared area of the spectrum, a substantial portion is re-emitted at a higher but still visible wavelength. An example is illustrated in Figure 8-5 representing a fluorescent "red" dye applied to a textile substrate (a comparable situation would obtain in case of a fluorescent pigment in a paint vehicle). The amount of emitted light depends on the concentration of the dye on the substrate but also on the intensity of the illuminating light at the wavelengths of absorption of the dye. Thus, different light sources will produce different intensities of emitted light. At the wavelengths of emission, the emitted light is added to the reflected light, generally resulting in light intensities exceeding that of the light falling on the sample. For this reason the sensations caused by fluorescent colorants are different from those caused by conventional colorants. They are on the borderline between nonrelated and related colors. The color sensations caused by the fluorescent colorants generally have a higher lightness than those caused by the surrounding objects, with the result that objects colored with fluorescent colorants appear to glow.

The measurement of the reflection and emission properties of fluorescent objects poses particular problems because of the dependence of the fluorescence on the illuminating light source. The determination of tristimulus values follows the usual rules. In the chromaticity diagram the colors caused by fluorescent colorants must fall within the area bounded by the spectral and purple lines. However, such colors can be located outside the envelope of optimal colors (Figure 6-18) since the lightness can exceed that of the corresponding optimal color. Some fluorescent colorants leading to chromatic color sensations are absorbing electromagnetic energy in the ultravi-

olet region and emitting it in the visible region. A number of minerals fall in this category as well as porphyrins, organic substances causing, for instance, the natural brownish color of brown eggs. Such eggs, illuminated by near-ultraviolet radiation, are seen as having a glowing red color.

Another group of such colorants are fluorescent whitening agents, products absorbing near-ultraviolet energy and emitting visible energy, mainly around 420 to 430 nm. They make "white" materials look whiter by masking the natural yellowish tinge of most "white" materials (textiles, paper, and so on) with emitted light. The appearance of materials treated with such products depends quite strongly on the properties of the illuminating light source, or the relative amount of near-ultraviolet energy contained in it.

When fluorescent colorants are mixed with nonfluorescent colorants, the combined effect depends on the degree of overlap of absorption and emission bands. The emission can be completely eliminated in combination with a colorant absorbing strongly in the region of emission of the fluorescent colorant. In mixes of fluorescent colorants, depending on the location of their absorption bands, they will compete for photons available for absorption and the emissions are not additive. Color gamuts involving fluorescent colorants are, therefore, quite complex in nature.

Colorants are convenient technological tools for the modification of transmission and reflection characteristics of materials and, therefore, for the creation of specific color sensations. There is a large number of colorants that are commercially available and new ones are being added almost daily. A wide gamut of color sensations can be produced, but because of the absorption characteristics of colorants the gamut is smaller than that achievable with lights. A very extensive technology has been developed for the application of colorants to materials so that the desired sensations are produced. Color physics, the colorimetric system, and color psychology have each aided substantially in the maturing of colorant application technology.

Footnotes

1. A few pigments, because of their transparent nature and the similarity of their optical properties to those of the vehicle, do not scatter light.

2. The laws of scattering are complex and beyond the scope of this text. Aside from particle size and shape, the refractive index of the colorant and other factors also play a role in determining the final result of scattering of a given material.

3. They have been found to be particularly useful for the identification of pigments. For this purpose the pigments are dissolved in various solvents and the absorption of the resulting solution is measured (Billmeyer, Jr., F.W.; Saltzman, M.; and Kumar, R., "Identification of Organic Pigments by Solution Spectrophotometry," *Color Research and Application* 7 (1982), pp. 327-337.

4. In theory these calculations work perfectly. In practice there is often a considerable number of difficulties reducing the accuracy of the calculated data. Detailed insight into these problems can be obtained in Stearns, E.I., *The Practise of Absorption Spectrophotometry*, New York, New York: John Wiley & Sons, 1969.

5. The law relating absorption to thickness of the transparent layer is known as Lambert's Law, after the German-French philosopher and scientist Johann Heinrich Lambert (1728-1777).

The law relating absorption to colorant concentration is known as Beer's law after the German physicist August Beer (1825-1863).

6. The mathematical formula in general use for relating reflectance and K/S is known as the Kubelka-Munk formula, named after the German physicists Paul Victor Kubelka (1900-1979) and F. Munk. A detailed discussion of the relationship of scattering and absorption is beyond the scope of this text. It is presented in Judd, D.B. and Wyszecki, G., *Color in Business, Science, and Industry*, op. cit.

7. K and S values can be determined in the absolute form or relative to a standard pigment (usually a "white" pigment). Various techniques for the determination have been proposed. For a particular scheme of the determination of relative K and S of pigments, see, for example, Kuehni, R.G., *Computer Colorant Formulation*, Lexington Massachusetts: D.C. Heath & Company, Lexington Books, 1975.

8. Masstone is the color sensation obtained from a coloration produced by incorporating a high concentration of pigment in a paint vehicle without additions of any other pigments (such as white or black).

9. Even though in this discussion parallels between color mixture and colorant mixture have been shown, the two are fundamentally different. Grassmann's laws of color stimulus mixture, for example, have no application in colorant mixture.

9

Color Reproduction

The reproduction of color sensations with technical means is an old problem. The artist wishes to recreate exactly the sensations experienced when looking at the objects of the still life. The artisan wants to duplicate for the masses the look of certain rare minerals (such as lapis lazuli), but with less expensive ingredients. The dyer needs to duplicate the color sensation created by viewing the fabric dyed by the competitor. The Sunday photographer (and the professional) wants the girl and the flowers in the picture to look exactly as they did when the photograph was taken. The paint manufacturer hopes to increase his sales by a line of paints duplicating "colonial" colors. The large retailer selling through catalogues wants the customer to have an accurate impression from the catalogue of the color sensations he will experience when looking at the purchased item. The problems are endless, the solutions often complicated and specific for the medium involved.

Following is a list of major technologies in which color reproduction is an important function and of the techniques used to produce color sensations:[1]

Color television
The picture is created by light emitted from three different phosphors leading to red, green, and blue primary sensations. Other sensations are created by

mixture of the three stimuli involved. Electrical impulses excite dots of phosphors in areas of the screen to various degrees, creating a variety of stimuli. The dots are not seen individually on the screen but create, over a larger area, an average sensation by color stimulus mixture.

Color photography
Transparent, photosensitive film layers, each containing one of three "primary" dyes, a "yellow," a "red," and a "blue" dye with varying spectral sensitivities form the basis of color film. Absorption of light of differing wavelengths and intensities causes none or some or all of the dye present in a certain area of the film to be sensitized. On development, the dye in these areas is converted to its final, light absorbing form. Not sensitized dye is removed during processing. The film layers are stacked on top of each other. Color sensations are created by viewing, in the case of transparencies (slides), light transmitted through the film layers. Color sensations other than those caused by the individual dyes are produced by colorant mixture, the combined absorption effect of two or all three dye layers on the light passing through. In the case of color prints the three transparent layers are attached to a "white," opaque background material. Light, after passing through the dye-containing layers, is reflected by the background.

Graphic printing
Most of the colored illustrations in magazines and advertisement flyers are printed by the so-called "four-color" process. The four colorants used produce yellow, red, blue, and black sensations. Intermediate color sensations are created by color stimulus mixture and colorant mixture. The colorants are usually printed on "white," semi-opaque paper in small partially overlapping dots not individually visible. Color-stimulus mixture occurs by visual integration over an area of the light reflected from dots. Where dots are overlapping, colorant mixture occurs because the ink layers applied are usually transparent. This creates additional spectrally different lights that become part of the stimulus and create new sensations.

When few and uniform color sensations from a large area are needed, they are usually produced by printing transparent or opaque layers of individual or mixed colorants onto the substrate material. If the colorant layer is transparent or semi transparent, the reflectance properties of the substrate will affect the result.

Dyeing and printing of textiles, coloring with paints, and other coloration techniques
Textiles are generally dyed or printed to match a reference material. The application of colorants to textile fibers changes their reflection properties. A similar situation applies in the case of paints: pigments in a film-forming vehicle are applied to the surface of materials to change their reflection characteristics. Other specialized coloration techniques follow the same pattern. In most cases the required color sensations (for standard viewing conditions) are achieved by the use of mixtures of colorants.

Figure 9-1 illustrates in the CIE diagram the approximate location of the three color primaries used in color television, the three colorant primaries

used in color photography, and the four colorant primaries used in graphic printing, together with the approximate gamuts covered by these primaries. The gamut illustrated for photographic primaries relates to transparencies; it is considerably smaller for prints.

At first glance it would appear that color reproduction could be based on colorimetry exclusively. Reflection or transmission properties of materials would be altered, using colorants, in such a way that identical tristimulus values are obtained for reference and colored sample. But because of contrast, adaption, and metamerism effects, satisfactory results by simple application of colorimetry are often not obtained. Colorimetric reproduction represents only the simplest case of color reproduction. It will generally result in metamerism since the spectral power distributions leading to the reference

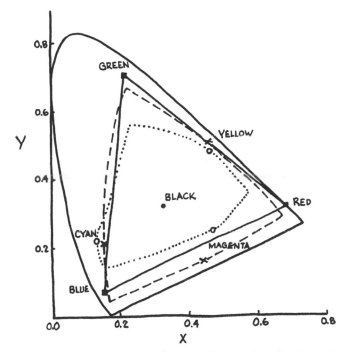

9-1. CIE chromaticity diagram, with approximate location and chromaticity gamuts of color television primaries (●━━━━), the three colorant primaries used in color photography (x - - - -), and the four colorant primaries used in graphic printing (o ·····).

sensations and those leading to the match sensations will usually be different. This applies in the case of color television, where color sensations are reproduced by an appropriate mixture of three primary lights, those caused by the three phosphor types in use. It obtains also in the case of color photography where there are three colorants involved, and in the case of "four-color" graphic printing based on four colorants.

In other cases (textiles, paints, and so forth) there is a large number of potential colorants available for the reproduction the color sensation caused by the reference material, reducing but not eliminating the problem of meta-

merism (see Chapter 4). Metamerism is usually unavoidable in three-primary or four-primary reproduction systems. In the case of color television and color photography it is of little consequence since the original scene and the reproduction are not seen simultaneously (until the arrival of "instant" color film). Accurate and nonmetameric matching is less a necessity than obtaining a reproduction that is pleasing overall. Color memory of certain objects helps suggest the proper known colors of these objects. In many cases the ability to discriminate is more important than color fidelity.

In color photography the effect of the light source can be troublesome. So that comparable sensations will result, all viewers involved should have similar color matching functions and the lighting conditions pertaining during the taking of the picture should apply when viewing the reproduction. On neglect of these factors substantial differences in appearance of the scene can occur. The situation described ignores the extensive effects of adaptation on the human visual system, however. If a scene is lighted with tungsten lamps, the observer is normally adapted and perceives the lamps as producing white sensations, not yellowish ones as the daylight-adapted observer does. Color film, on the other hand, does not have have an adaptation mechanism. When taking a color photograph of a scene that is lighted with tungsten lamps using a "daylight" film, the resulting transparency or print will cause distinctly yellowish sensations from reproduced objects. The problem is overcome for the most common adaptation situations with the help of filters or specially prepared films. It is a necessity for a photographer to learn, either by trial and error or, better, by specific experiments and calculations using the CIE colorimetric system the effects of various artificial light sources, filters, and film properties on the quality of reproduction achieved.

In the case of graphic printing, color fidelity can range from unimportant to very important. It is relatively unimportant in the case of news-related pictures or general, entertaining material. It is more important with advertising photos and highly important for mail-order catalogues and fine-art reproductions. In the latter cases, effects of color constancy, metamerism, and adaptation can become troublesome. When viewed in certain types of illumination, elements of the reproduction may cause color sensations substantially different from those created by corresponding elements in the original scene.

A particular problem in color photography and graphical printing is posed by colors that cannot be reproduced by the technical process. Imagine a scene containing elements producing sensations of low chroma and others that have very high chroma (caused by certain flowers, for example). The reproduction process can easily cope with low chroma sensations but is incapable, because of lack of suitable colorants, to reproduce the high chroma sensations. They will be reproduced at the highest chroma level achievable with the available colorants. The reproduced scene is now out of balance compared to the original scene. In such a case it is necessary to scale the chroma of all elements in the scene in such a way that the overall color balance (specifically the chroma differences between adjoining areas) remains the same. The color fidelity of the reproduction of all elements of the scene may be relatively low in a colorimetric sense but the reproduction is

considered satisfactory because all areas of the scene are perceived to be in balance.

Another important effect on color fidelity is that of surround. It is caused by simultaneous contrast (see Chapter 4) and is much larger for picture elements bordering on the surround than those in the center of the picture. The effect is related, in part, to the general brightness level of the surround. It is most easily demonstrated in the case of color television. If viewed in daylight, the picture looks washed-out and dull. As the surround darkens the picture becomes increasingly more colorful and bright. A similar effect can be demonstrated in color photography with transparencies and prints of a given scene. These can be adjusted so that the tristimulus values associated with elements in the scene are identical in given viewing situations. If the slide is viewed in dark surround (as it generally is) and the print in daylight surround, the resulting color sensations can be substantially different despite identity of tristimulus values of all elements in the pictures.

Extensive psychological studies have disclosed culturally induced preferred colorations of certain objects. In general, higher chromas are preferred; the sky in the reproduction should look, if possible, bluer than the original, the sunset redder, and the grass greener. Caucasian skin color should preferably look tanned rather than pale. As a result, the average television set is tuned to produce much higher saturation than those caused by the original scene. Such coloration preferences are also often considered today by the makers of color film and the producers of reproductions by graphic printing.

Despite an increasing array of technical aids, color reproduction by photography and graphic printing remains largely an art. Sophisticated scanning devices can be used to adjust the transmitting or reflecting properties of certain elements of the reproduction in a technically very clever way but the adjustment is largely based on the aesthetic values of the operator of the scanner. However, continuing psychological studies of the judgment of the quality of a reproduction by the average viewer and increased use of spectrophotometers and more sophisticated scanners may pave the way for more objectivity in color reproduction in these technical fields.

The highest level of color fidelity is usually achieved in color reproduction involving colored materials such as paints, textiles, plastics, and so forth. Because of the problems of metamerism it is generally not sufficient to produce colorimetric matches, or matches leading to identical tristimulus values. In order for the material to have the same appearance as the reference material in all illumination situations, the spectral characteristics of the reference material (the transmittance or reflectance properties) need to be reproduced exactly.[2] This is usually only possible if identical materials and colorants are involved in the case of reference and batch. Often this does not apply and it is necessary to find the optimal compromise between color fidelity, technical properties of the colorants, and their economics. Several hundred dyes and dozens of pigments are being produced commercially, giving the colorist a wide choice of absorption and other technically important properties, as well as price. With dyes the choice is narrowed in that only certain types of dyes can be used on specific substrates (different types of dyes have to be used, for example, to dye cotton as compared to

dyeing wool). The choice may be narrowed further by technical application requirements and resistance of the colorants to degradation.

Perhaps the most important degradation is that caused by light. Colorants have only a limited ability to absorb photons. Sooner or later, particularly also under the influence of moisture and atmospheric contaminants, colorant molecules are being destroyed. This results in reduced absorption, an effect called fading. Certain colorants are destroyed after only hours of exposure to daylight while others may be stable for years. There are many other important degradation effects, particularly for dyes applied to textiles. They need to be taken into account in the selection of colorants for a particular coloring task.

The requirements for color fidelity in the technologies under discussion are very high and increasing. The maker of garments wants to be able to use many pieces of dyed fabric (typically about one hundred yards long) to cut dozens of front and back panels of jackets simultaneously. If he receives a repeat order he wants to be able to use up any leftover goods from the previous order together with the new shipment. The plastics manufacturer must be able to color his product with a fidelity such that it can be mounted next to another part made by another manufacturer in, say, the assembly of a car, and match. The paint maker must ensure that the paint used in the repair of the body of a car matches the original paint so that it is not necessary to repaint the car completely. Many more examples could be offered.

The responsibility of ensuring the color fidelity and color fastness at a competitive cost belongs to the colorist. Today, as in the past, colorists use their working experience to achieve this goal. Years of working with materials and colorants and of testing their properties have given them the capability of making the right choices. More and more, however, they are aided by color measurement and computation to find optimal colorant formulations for achieving colorations with the required color fidelity at lowest cost. The technology in use is known as instrumental colorant formulation or, more commonly, as computer color matching. It is perhaps the most successful commercial application of color science. Hundreds of color measuring instruments and associated digital computers are used by industry to provide original formulations to reproduce the color sensation caused by the reference material as well as corrective formulations, used during manufacturing processes.

Several conceptual approaches are in use. The most commonly employed approach relies on matching the tristimulus values of the reference material, as determined from reflection measurement. In order to be able to provide a computed formulation producing a color sensation identical to that produced by the reference material, several requirements must be met.[3] We need:

> —a numerical method with which to define the color sensation caused by the reference material when viewed under standard conditions. This requirement is well met by the CIE colorimetric system.
> —information on the relationship between colorant concentra-

tion and measured reflectance factor and an equation linear-
izing this relationship. The most commonly used equation is
that published by Kubelka and Munk (see Chapter 8).
—an equation system and an algebraic method to solve for the
unknown dye concentrations, the formulation. A typical meth-
od is described briefly below.
—a color difference formula to test the formulation for accuracy
relative to the reference material and to evaluate the degree
of metamerism of the formulation. Typically, the CIELAB
formula is used and color differences, or indices of metamer-
ism, are calculated for at least three illuminants.

Matching the tristimulus values of the reference material is usually not
difficult if it is possible to use several colorants. However, to provide a for-
mulation exactly matching the reflectance-factor curve of the reference
material and, therefore, producing an identical sensation under any light
source, is usually impossible because of a lack of suitable colorants. This is
especially the case if reference material and material to be colored are
different, e.g., if the color caused by a Munsell chip is to be duplicated on
wool. The degree of metamerism resulting from the formulation in such a
case depends entirely on the degree of similarity of the absorption proper-
ties of the colorants used in the reference material and the material to be
colored. Conventionally, the colorist works with one colorant combination,
determining by trial and error the concentrations necessary and, perhaps,
making some colorant substitutions if a satisfactory match cannot be made.
The advantage of instrumental formulation is that all possible combinations
from a sizable number of colorants can be tested by calculations and the
optimal combination (in respect to metamerism and economics) can be
found rapidly.

We have said that colorant formulation programs usually attempt to
duplicate the tristimulus values of the reference material. As discussed in
Chapter 6, tristimulus values are determined by multiplying, at certain wave-
length intervals, the spectral reflectance factor with the product of color
matching function values and spectral power distribution function values of
the illuminant. The latter values are found in tables and are identical for
reference and match. What is needed is to create, by addition of colorants
to the substrate, a reflectance curve resulting in tristimulus values identical to
those of the reference material. The theoretical reflectance factor curve of
one or more dyes at any given concentration can be calculated. What is
required is the determination of the reflectance data resulting from applica-
tion of unit concentration of the dye on the substrate (e.g. one percent on
the weight of the textile material) and the use of a linearizing relationship
between dye concentration and reflection, such as that put forth by Kubelka
and Munk.[4] In the formulation program, this situation is inverted and the dye
concentrations required to produce certain reflectance properties (or rather,
the associated tristimulus values) are sought. In the typical application of
three dyes, a set of equations with three unknowns (the colorant concen-
trations) is set up. Known values in the equations are the tristimulus values of
the reference material and the tristimulus values of colorations of unit con-

centrations of the dyes to be used. The equation system is solved using standard algebraic methods, resulting in concentration values for the three colorants (concentrations for more or less than three colorants can also be calculated). This initial solution is tested by computation of the reflectance curve theoretically resulting from application of the colorants (by multiplying the calculated concentrations with the unit Kubelka-Munk values, totaling them at each wavelength, and converting to reflectance). The tristimulus values associated with the calculated curve are computed and compared to those of the reference material. In theory they should be identical. Because of imperfect linearity of the relationship between colorant concentrations and related K and S constants, rounding errors, and other difficulties, there is frequently a difference between the two sets of numbers. The initial solution is now improved by what is called an iterative technique, producing new solutions, each improving on the previous one until the two sets of tristimulus values are identical or near-identical.

Color-difference calculation can be used to determine if the solution is sufficiently accurate. When it is, indices of metamerism and cost of the formulation are usually calculated. Because of the complexity of the calculations, high speed computers are necessary. The calculations result in none, one, or, usually, several formulations for a given reference material. The colorist can select a formula based on whatever criteria he needs to comply with and test it in the laboratory. Because of the large number of variables involved in the coloration process and incomplete control of some of them, the laboratory test of the computed formula does not always result in a satisfactory coloration. A correction of the formulation can be done on a trial-and-error basis or by calculation techniques similar to those described above. Similarly, during the commercial coloration process, deviations in color that require adjustment of colorant concentrations can occur. Reflection measurement and calculation can also in this case be used for rapid correction.

There is a considerable effort required to make instrumental colorant formulation work: the system represents a substantial investment, calibration colorations of all colorants that can potentially be used in a given process must be prepared and their reflection data stored in the system, and so forth. In most cases very solid user savings result. But it should be understood that instrumental colorant formulation is not a foolproof technology. There is a large number of possible causes for deviations between results expected and those obtained, keeping colorists and technicians on their toes and occupied with trying to find better methods and better control of variables. The substantial number of instrumental systems in worldwide use attests to the solid success of the technique, however.

Color reproduction is a complex technological field of considerable importance. The problems to be solved are generally quite specific to the coloration process involved. Color fidelity of the reproduction can range from poor to perfect. Often, for a variety of reasons, perfect reproduction is impossible. In many cases color is used solely for the purpose of increasing the level of discrimination or for esthetics, and an exact reproduction is immaterial. It is a general rule that process costs increase with an increase in

color fidelity. Moderate fidelity is often an economic necessity. Color fidelity of the reproduction is sacrificed at times in the interest of preferred coloration. Color psychology, colorimetry, and color science in general have aided substantially in the refinement of reproduction techniques and will do so increasingly in the future. But it is obvious that in many respects, color-reproduction technology is and will remain an art, drawing on the aesthetic sense of the practitioner.

Footnotes

1. These color reproduction processes are described only sketchily. For a more detailed description, consult an encyclopedia or appropriate technical books.

2. For an exact duplication of appearance, not only identity of transmission or reflection characteristics but also of other appearance parameters, such as surface characteristics of the object, is necessary.

3. For a more detailed description of instrumental colorant formulation see Kuehni, R.G., *Computer Colorant Formulation,* op.cit.

4. The Kubelka-Munk relationship is used as a single constant (K/S) for dyes and separate constants (K and S) for scattering colorants.

Appendix
Color and Man[1]

To what extent early man was conscious of colors is not known. It is likely, however, that when evolving homo sapiens, man's physiological apparatus of color vision was developed to the same level at which it exists today, that early man had the same sensory response to the visual spectrum as man has today. Until the advent of language, the response was a purely animalistic one comparable to that of higher mammals: color helped distinguish between friend and foe, between edible and poisonous matter, between safe and treacherous passageways. Color was not recognized as a separate entity but was taken to be a part of the objects it was associated with. In general, it was a very valuable—if unrecognized—tool in the fight for survival.

The arrival of higher brain functions, consciousness as we know it, and language eventually brought with them an awareness of color as an entity separate from form. When and how man became consciously aware of colors is not known. At first he was probably aware of colors as sensations. At a later point verbalization of color sensations began, a chain-of-development theory that perhaps can be supported by the demonstrable fact that, as experiments have shown, very young children understand com-

plicated events based on observation without being able to verbalize them. The development of language appears to have led to a separate functional activity of the two lobes of the brain (see Figure 1-1, Chapter 1).

Experiments have indicated that colors are more quickly perceived in the right hemisphere of the brain but are verbalized almost exclusively in the left hemisphere by the average right-handed person (the majority of humans are right handed). If this is correct, it points to a fundamental difference between simple perception and verbalization. Studies of basic color terms indicate that man's first color-related verbalized concepts may have been light and dark, out of which *white* and *black* eventually developed as separate concepts. The first chromatic concept appears to have been red.[2] We can only speculate on the reasons: blood and fire, both highly important aspects of the life of early man. It was followed by the concepts of yellow and green, later that of blue, and eventually the whole group of secondary chromatic concepts: orange, purple, brown.

A curiosity about the nature of color in Western culture is first documented in the writings of Greek philosophers. Because sensation and perception are central to our understanding of the world we live in and color sensation is perhaps the most important result of the action of the senses, it is not surprising that the explanation of the nature of color remained an important philosophical endeavor until science assumed a status independent of philosophy.

Pythagoras, active around 500 B.C. and famous for his contributions to mathematics and geometry, attempted to explain color. No writings of his on the subject remain, but he has been quoted as believing that vision is due to a hot emission from the eyes being reflected upon encountering the cold objects surrounding the viewer. His disciples declared that objects have an appearance, called opsis, which extends in all directions and, on meeting a mirror, is pushed back by the hardness and slickness of the surface. They called the surface of objects, their skin, chroma, a term that eventually came to have a meaning related to color. His disciples also distinguished between four families of color: white, black, red, and yellow, the differences between them believed to be due to differences in the elements constituting matter. Pythagoras and his disciples appear to have been the founders of the emission theory of vision according to which vision is activated by an emanation from the eyes. Color, on the other hand, they believed to be located on the surface of objects.

Empedocles, a philosopher, prophet, and scientist active around 440 B.C. is probably the founder of another theory, the emission-immission theory, according to which energy from the eye and energy flowing to the eye intermingle and cause the sensations of vision and color. He postulated the existence of the elements fire and water in the interior of the eye with the other two elements, air and earth, remaining outside of the eye. The eye has pores through which fire and water can penetrate. Penetrating fire leads to a sensation of white, water to one of black. At the same time he believed objects to have an effluence bringing colors to the eye. Empedocles related elements and basic colors as follows: fire-white, water-black, air-yellow, earth-red.

A third theory, the immission theory, according to which there are effluences from matter flowing to the eye and causing sensations of light and color, can be traced to Democritus, active around 420 B.C. and founder of the atomic theory of matter. He believed that color is nothing in itself but created by certain arrangments of the elements. He also recognized four basic colors: white, black, yellow, red.

The philosopher Plato (427?-347 B.C.) was perhaps the strongest proponent of the emission-immission theory. At the same time, he found the color problem intractable. He was critical, in general, of Democritus' ideas on color but accepted his view of the four basic colors. These colors he believed to be created by the simultaneous action of energy emitted from the eye and energy flowing to the eye. Other colors are created by mixture of the four basic colors such that redness mixed with black and white produces purple, gray is created from black and white. Brightness combined with white and falling on pure black produces a blue sensation, yellow and gray produce brown, brown and black produce green sensations.

The philosopher Aristotle (384-322 B.C.) expressed himself on the subject of color in several of his works. Some of his statements appear to be contradictory and are perhaps a sign of the development of the philosopher's thinking on the subject. At times he appears to have adhered to the immission theory, at other times to the emission theory. He wrote that the potential of color in the object and the potential of transparency in the medium between object and eye are activated by light. Light has no substance and is the presence of the element of fire in the transparent medium. An absence of fire is darkness. In objects the presence or absence of fire causes white and black sensations, respectively. Other colors are created by various means. One of these, as suggested by Aristotle, is mixture of black and white. Black and white [colorants] can be so small that they are not seen as such in mixtures, but as different colors.[3] In this way many colors can be created out of black and white, some by ratios, others by addition or subtraction. This particular theory, confusing as it appears to be, has had adherents for many centuries, as will become apparent later. Aristotle recognized seven classes of colors—white, yellow, red, violet, green, blue, and black—and compared these to seven basic flavors.

The disciple and successor of Aristotle, Theophrastus (372-287 B.C.), wrote a brief work under the title *On Colors* that is often considered to represent Aristotle's final thinking on the subject. In it he described colors as being the result of various kinds of light sources, the influence of the transparent medium and the reflection from the surrounding objects. He distinguished between simple colors (white, yellow, black) and mixed colors (all others). The former are those accompanying the elements: air and water are white, fire is yellow, earth is originally also white, black results from the transformation of one element into another. All other colors result from mixture and interaction of the three basic colors.

Early attempts to explain color sensation were hampered by the multitude of color phenomena with seemingly contradictory causes and the need to explain all of them with a coherent theory. The inclusion of mystical concepts and artificial relationships (e.g., the comparison of fundamental

elements and colors) was not helpful for a lucid explanation. The concepts of the classical Greek philosophers, particularly Plato and Aristotle, remained authoritative until the late Middle Ages. The Romans, even though masters in the use of color in art and decoration, added little or nothing toward a better understanding. The poet Lucretius (99-55 B.C.) in his *De rerum natura* presented the immission theory in the form of verses without adding to it. The early Middle Ages produced numerous commentators of the classical Greek philosophers, foremost among them a number of Arabs: al Kindi, Averroes, and Alhazen. While generally translating their sources faithfully, they occasionally departed from them and, in particular, they rejected Aristotle's emission theory. In an otherwise dark age they and a number of monks (Augustine, Roger Bacon, and others) kept the philosophical tradition alive and with it consideration of color phenomena, without adding significant new insights.

The flowering of painting and architecture during the Renaissance period resulted in a considerable involvement with color theory and extensive consideration of those of the Greek philosophers. Theories of painting abounded as well as theories of vision and color. These were generally slanted toward painting and did not result in significant new insights into the nature of color. The Italian architect and painter Leone Battista Alberti (1404-1472) discussed in his book *On Painting* the necessity of light for the appearance of color. He recognized four basic colors corresponding to the four elements: red for fire, blue for air, green for water, yellow for earth. He expressly rejected the Aristotelian theory that black and white can be the sources of all other colors. Perhaps for this reason he did not recognize black and white to be basic colors. Nevertheless, he seems to have been the first to propose what basically is an opponent-color system.

The sixteenth century saw an intensification of thinking and experimentation that led to a relatively rapid development of natural philosophy, the forerunner of modern science. The development of book printing in the late fifteenth century had caused a wider distribution of the works of the Greek philosophers, enlarging the number of people that considered the truth of their pronouncements. The Italian philosopher Berhardinus Telesius (1508-1588) published in 1570 the small book *On the Generation of Colors*, in which he described his theory of matter being modified by two immaterial principles that can be sensed: heat and cold. He believed heat and cold to be also responsible for colors. This represented a significant if not completely successful departure from Platonic and Aristotelian thinking.

Francis Bacon (1561-1626), Lord High Chancellor of England and philosopher, writer of a considerable number of philosophical essays, pleaded in his *Novum Organum Scientiarium* for abandonment of the method of pronouncements of early philosophy and the use of the inductive method applied in modern science. He recommended full investigation of the facts and an avoidance of theories based on insufficient data. Previously, the pronouncements of the early philosophers, particularly Plato and Aristotle, were largely considered to be unassailable and newly discovered facts had been explained so that they fit into the existing framework of thought. Bacon rejected this approach for one of experimental determination of facts

and verfication of theories. While he did not contribute significantly to color theory, he opened the way for unencumbered inquiry and new experimental approaches. His contemporaries Johannes Kepler (1571-1630) and Galileo Galilei (1564-1642) revolutionized astronomy and sharpened the conflict between old, church-sanctioned views and the new knowledge based on observation and experiment.

With the development of the lens, the microscope, and the telescope, optics became an important part of natural philosophy and led to intensive study of reflection (catoptrics) and refraction (dioptrics). Both of these processes are closely connected with the phenomena of colors. Marcus Antonius de Dominis (?-1624), an Italian, had a book published in 1611 with a theory of the telescope in which he discussed colors created by refraction. He described these colors as arising from light or, in fact, being light themselves. He saw colors as the result of an addition of darkness to light. The book also contains a quite accurate explanation, based on refraction, of one of the most fascinating color phenomena: the rainbow.

The seventeenth century, in general, represents the cradle of modern color theory, culminating in the writings of Newton. Among his immediate predecessors was René Descartes (1596-1650), the French soldier, philosopher and mathematician. He described a theory of color founded on a corpuscular theory of light. According to Descartes the particles of light are of different speed and rotation. Depending on speed and specific movement, they produce in the eye and brain various sensations of color. Descartes also contributed significantly to the explanation of the rainbow. The Jesuit priest Athanasius Kircher (1601-1680) had a book published in 1646 in which he described light, shadow, and color as the major elements of vision and colors as resulting from the interaction of light and shadow. He described color as shaded light and was the first to explicitly propose a theory later expanded and championed by the German poet Goethe.

The Dutch scientist Isaac Vossius (1618-1689) can, in a sense, be considered the immediate forerunner of Newton. In his book *On the Nature and Properties of Light*, published in 1662, he expressed his views, following Telesius, that colors in objects are caused by heat. He supported this with the observation that in warm or tropical countries nature is more colorful and colors are more intense than in cold countries where colors tend toward white. However, the so-called apparent colors, those in the rainbow or caused by other refractive effects, he explained as follows: "Since the flame contains all colors, it is necessary that the light [emanating from the flame] has the same property. Therefore, all colors are contained in light, though they are not always visible. As a strong flame appears white but assumes various colors when viewed through a fog or other dense medium, so light, even though it is invisible or white, if passed through a prism or through humid air, assumes various colors."

The English physicist and chemist Robert Boyle (1627-1691) is the author of the book *Experiments and Considerations Touching Colours* (published in 1664), in which he classified the major schools of color theory existing at the time:

1. the Aristotelian school
2. the Platonic school, with its emission theory
3. the atomistic school, which considered color to be an emission of the object carried to the eye by light
4. the Kircherian school, explaining colors from a mixture of light and shadow
5. the chemical school, explaining colors as caused by the then accepted three elements (sulfur, salt, and mercury, replacing the classical four elements fire, air, water, and earth)
6. the Cartesian school, explaining the sensation of light by the impact of light particles on the optic nerve and those of colors by the differing speed and movement of the light particles

Boyle himself explained white and black as due purely to reflection. He did not consider himself competent to explain chromatic colors, preferring the general theory that light rays are being modified by objects from which they are reflected or through which they pass and, after this modification, produce sensations of color in the visual apparatus. He presented many intelligent unanswered questions on the nature of color and believed it to be largely unexplained at his time.

At the same time, however, his fellow member in the Royal Society of London, Isaac Newton (1642-1727), was hard at work to develop his *New Theory about Light and Colours*. Newton turned out to be the pre-eminent scientific thinker of his time, having made many highly important contributions to mathematics, physics, and astronomy. He presented his insights into color phenomena to the Royal Society in 1671, and they were published in the Transactions of the Society in 1672. His book *Opticks*, published in 1704, summarized his thinking on the subject. He showed that the light of the sun consists of rays that are refracted differently by a prism. Rays that are refracted in a certain way result in specific color sensations. The apparent color of these bands (under standard viewing conditions) cannot be changed by further refraction or reflection. He recognized seven original and simple colors: red, orange, yellow, green, blue, indigo, and violet-purple. Other colors are compounds of these. White and gray can be compounded from simple colors and the whiteness of the sun's light is a mixture of all the simple colors, mixed in a certain proportion. Newton used a color circle to explain in quality and quantity the color of mixtures of light rays. On the basis of his theory he was able to explain most color stimulus phenomena, at least in a general sense. His findings, which he presented in the form of theorems, were supported by meticulously devised experiments. Nevertheless, Newton faced considerable scepticism and criticism during his lifetime. But more and more scientists, by recreating Newton's experiments, convinced themselves of their truth and Newtonian theory soon became the generally accepted theory.

The new discoveries and insights into color phenomena also resulted in technological advances in color reproduction. It was already known in classical Greek and Roman times that a multitude of hues can be created by

use of a very limited number of pigments. But it appears to have been the discovery of the French artist and printer Jacques Christophe Le Blon (1667-1741) that by proper use of three or at most four pigments ("yellow," "red," "blue," "black") color prints displaying a wide variety of hues could be produced in printing. Seemingly by intuition he learned how to engrave pictures on multiple plates to which one each of the pigments was applied, so that on printing, by the processes of color stimulus mixture and colorant mixture, a variety of hues at many levels of chroma resulted. He was the early inventor of the four-color graphic printing process.

Newton presented the physical principles governing the color stimulus correctly but he did not attempt to explain man's color vision mechanism. At that time the anatomical details were largely known. When it was recognized that stimulus phenomena had been correctly explained by Newton, interest and emphasis began to shift to the color vision mechanism. In 1777 English physician George Palmer had his book *Theory of Colours and Vision* published; in it he proposed (incorrectly) that each ray of light is composed of three rays leading to yellow, red, and blue sensations and (approximately correctly) that the surface of the retina is compounded of particles of three kinds. Complete and uniform motion of these particles produces the sensation of white, while the absence of motion produces the sensation of black. Incomplete and irregular motions, on the other hand, cause the sensations of chromatic colors. His book also indicates a rudimentary understanding of the process of adaptation. Because Palmer's work was lost for a long period of time, the idea of three types of receptors in the retina is usually credited to the English physician Thomas Young (1773-1829) who proposed it before the Royal Society in 1802.

Perhaps the last important challenge to the Newtonian theory was made by the man considered to be the greatest poet of the German language, Johann Wolfgang von Goethe (1749-1832). He thought himself a poet among many but was convinced that he was the most knowledgeable person of his time in the field of color. His ideas are presented in his *Farbenlehre*, which describes an extensive series of experiments and many significant insights into color phenomena. In essence, Goethe subscribed to the theory that colors are created by an interaction of light and shadow and he vehemently denied the validity of the Newtonian theory. The German philosopher Artur Schopenhauer (1788-1860), introduced to color by Goethe, parted ways with him on the question of the composition of sunlight. He wrote that colors, their appearance and relationships, are nothing but specific modifications of the activity of the retina and that the external stimulus contributes only subordinately to the creation of color sensation.

The theoretical basis of color mixture, involving three types of receptors, was fully developed by the German mathematician Hermann Günter Grassmann (1809-1877), resulting in what are known as Grassmann's laws of color mixture (see Chapter 6). Further important contributions to the theoretical aspects of color vision were made by the English physicist James Clerk Maxwell (1831-1879). He experimented extensively with what is known as Maxwell's disk (see Chapter 5), proposed a quantitative triangular color diagram, and developed a simple colorimeter for the study of color mixture.

His contemporary, the German physicist and mathematician Hermann Ludwig Ferdinand von Helmholtz (1821-1894), expanded on Young's theory of color vision mediated by three receptor types and proposed spectral sensitivity curves for them.[4] He also clarified the differences between color stimulus mixture and colorant mixture and proposed a system of color classification based on the quantity of a spectral colored light, its wavelength, and the quantity of white light required to be mixed with it to result in the to be specified color sensation. These measures are known as dominant wavelength and purity (see Chapter 6). It appears that von Helmholtz was the first to devise a mathematical treatment of color space, a color metric, based on theoretical considerations, that allowed the calculation of color differences.

The effects of adaptation, long recognized, were studied by the German physiologist Johannes von Kries (1853-1928). He showed that the color equations, the rules of additivity of color stimuli, normally persisted under various kinds of adaptation, and he devised a simple mathematical formula to predict the results of adaptation.

Extensive experimental work had convinced the German physiologist Ewald Hering (1834-1918) that the Young-Helmholtz theory did not satisfactorily explain all his findings. He proposed the opponent-color theory which posits three fundamental opponent-color pairs of sensations, white-black, red-green, and yellow-blue, as basis of color sensation (see Chapter 3). Hering's theory was adopted by the German chemist Wilhelm Ostwald (1853-1932) who based his color order system on it. After having been relegated to the background, Hering's theory has found important experimental support in the last few decades and is today one of the pillars of color theory.

The attentive reader has noticed an increasing mathematization of color theory starting with Newton. An extensive mathematically based theory of color vision was devised early in our century (1920) by the German mathematician, physicist, and cofounder of quantum mechanics Erwin Schrödinger (1887-1961). He developed equations similar to those used later in the CIE colorimetric system, allowing one to determine which spectral power distributions lead to matching sensations. He called this system "basic color measurement." Under the heading "advanced color measurement" he devised a new metric of color resulting in a color difference formula.

With Schrödinger we have arrived in our century where color science appears to have reached substantial maturity. More exact determination of the spectral brightness function and the color matching functions led to the development of the CIE colorimetric system. Fundamental studies of color difference evaluation have initiated a lengthy, and ongoing, discussion on this subject. Several color order systems, differing in detail of construction, have been developed (refer back to Chapter 5). Since the 1950s increasing technical sophistication of physiology and psychology has led to fundamental insights and data concerning the anatomical/physiological construction and functioning of the visual apparatus. The development of the theory of relativity, atomic physics, and quantum mechanics has produced the detailed understanding of color stimuli discussed in Chapter 2.

Despite the considerable progress in understanding color phenomena

made in the last three centuries, the process is not finished and it is likely that it never will be. Any new theory—and there are new ones offered frequently—must cope with an enormous amount of existing experimental data to which there is being added more every day. A new comprehensive theory must be able to account for all these data. New theories, therefore, often cover only a limited aspect of the complete color-vision system.

The concentration of science on the explanation of the mechanistic, quantitative aspects of color phenomena has left many artistically creative people dissatisfied and has produced a chasm in understanding and communication between the artistic and scientific communities. Artists and psychologists have earnestly struggled with qualitative aspects of color, with theories of esthetics and color harmony. Poets, artists and philosophers have investigated the spiritual aspects of color. But the difficulty in attempting to apply the inductive scientific technique to these questions has left many observers in doubt about the fundamentality of the reported results.

Color is an intensely human phenomenon. Its explanation has occupied many of the greatest thinkers, if often only as a sideline. Many aspects are still largely unresolved, offering opportunities for inquiry to satisfy the perennial curiosity of mankind about itself and its place in the world.

Footnotes

1. An extensive description of the development of ideas about color would of necessity be of book length. This appendix provides only the barest outline.

2. We follow here the theory presented in Berlin, B., and Kay, P., *Basic Color Terms*, Berkeley, CA: University of California Press, 1969.

3. An intermingling of the concepts of color and colorant is apparent here. Such confusion has persisted down to our present time.

4. The three-receptor theory is now known as the Young-Helmholtz theory.

Bibliography

Literature citations purposely have been kept to a minimum in order not to
overwhelm the reader with references.

For the reader looking for more detailed information at the next highest level
of complexity, the following book (with a strong technological orienta-
tion) is recommended:

Billmeyer, Jr., F.W., and Saltzman, M. *Principles of Color Technology*,
second edition. New York, New York: John Wiley & Sons, 1981.

A recommended text of more advanced technological orientation is:

Judd, D.B., and Wyszecki, G. *Color in Business, Science, and Industry*,
third edition. New York, New York: John Wiley & Sons, 1975.

Recommended advanced texts with psychological orientation are:

Boynton, R.M. *Human Color Vision*. New York, New York: I lolt, Rinehart
and Winston, 1979.

Hurvich, L.M. *Color Vision*. Sunderland, Massachusetts: Sinauer Asso-
ciates, 1981.

(All of the books above contain extensive literature citations enabling the reader to penetrate deeper into individual aspects of the complex subject of color.)

For further reading on the historical aspects of color theory, the following work is recommended:

von Goethe, J.W. *Geschichte der Farbenlehre*. Translation in: von Goethe, J.W. *Color Theory*. Translation by C.L. Eastlake. Cambridge, Massachusetts: The MIT Press, 1970. It represents a history, if biased, of early color theories.

A selection of important original texts in color science (some in translation) is offered in:

MacAdam, D.L., editor. *Sources of Color Science*. Cambridge, Massachusetts: The MIT Press, 1970.

Cited references

Berlin, B. and Kay, P. *Basic Color Terms*. Berkeley, California: University of California Press, 1969.

Billmeyer, Jr., F.W.; Kumar, Romesh; and Saltzman, Max. "Identification of Organic Colorants in Art Objects by Solution Spectrophotometry." *Journal of Chemical Education* 58 (1981).

Birren, F. *The Color Primer: A Basic Treatise on the Color System of Wilhelm Ostwald*. New York, New York: Van Nostrand Reinhold, 1969.

Boynton, R.M. *Human Color Vision*. New York, New York: Holt, Rinehart, and Winston, 1979.

Brindley, G.S. and Lewin W.S. "The Sensations Produced by Electrical Stimulation of the Visual Cortex." *Journal of Physiology* 196 (1968).

Eccles, J.C. *The Understanding of the Brain*, second edition. New York, New York: McGraw Hill Book Company, 1977.

Evans, R.M. *The Perception of Color*. New York, New York: John Wiley and Sons, 1974.

von Goethe, J.W. *Color Theory (Farbenlehre)* Translation by C.L. Eastlake. Cambridge, Massachusetts: The MIT Press, 1970.

Hard, A. and Sivik, L. "NCS-Natural Color System: A Swedish Standard for Color Notation." *Color Research and Application* 6 (1981).

Grassmann, H.G. "Zur Theorie der Farbenmischung." *Poggendorffs Annalen der Physik* 89 (1853). As translated in MacAdam, D.L., editor, *Sources of Color Science*, op. cit.

Hering, E. *Outlines of a Theory of the Light Sense*. Translation by L.M. Hurvich and D. Jameson. Cambridge, Massachusetts: Harvard University Press, 1964.

Hubel, D.H. and Wiesel, T.N. "Brain Mechanisms of Vision." *Scientific American* 241 (1979), No.3 (September). .

Hunt, R.W.G. "The Specification of Colour Appearance. I. Concepts and Terms", *Color Research and Application* 2 (1977).

Hurvich, L.M. *Color Vision.* Sunderland, Massachusetts: Sinauer Associates, 1981.

Huxley, A. *The Doors of Perception.* London: Chatto & Windus, 1954.

Judd, D.B. and Wyszecki, G. *Color in Business, Science, and Industry,* third edition. New York, New York: John Wiley & Sons, 1975.

Kuehni, R.G. *Computer Colorant Formulation.* Lexington, Massachusetts: D.C. Heath & Company, Lexington Books, 1975.

Kelly, K.L. and Judd, D.B. *The ISCC-NBS Method of Designating Colors and a Dictionary of Color Names.* Washington, D.C: U.S. Government Printing Office, National Bureau of Standards Circular 553, (November 1) 1955.

Kelly, K.L. and Judd, D.B. *Color: Universal Language and Dictionary of Names.* Washington, D.C.: U.S. Government Printing Office, National Bureau of Standards Special Publication 440, 1976.

MacAdam, D.L., editor. *Sources of Color Science.* Cambridge, Massachusetts: The MIT Press, 1970.

MacAdam, D.L. "Uniform Color Scales." *Journal of the Optical Society of America* 64 (1974).

MacAdam, D.L. *Color Measurement: Theme and Variations.* New York, New York: Springer Verlag, 1981.

Nassau, K. "The Causes of Color." *Scientific American* 243 (1980), No. 4 (October).

Nickerson, D. "OSA Uniform Color Scale Samples: A Unique Set." *Color Research and Application* 6 (1981).

Richards, W. "The Fortification Illusions of Migraines." *Scientific American* 224:13 (May) 1971.

Robertson, A. "The CIE 1976 Color Difference Formulae." *Color Research and Application* 2 (1977).

Saltzman, M. and Keay, A.M. "Colorant Identification." *Journal of Paint Technology* 39 (1967).

Schrödinger, E. "Grundlinien einer Theorie der Farbenmetrik im Tagessehen," *Annalen der Physik 63* (1920). As translated in MacAdam, *Sources of Color Science,* op. cit.

Sears, F.W.; Zemansky, M.W.; and Young, H.D. *College Physics*, fifth edition. Reading, Massachusetts: Addison-Wesley, 1980.

Society of Dyers and Colourists and American Association of Textile Chem-

ists and Colourists. *Colour Index*. Third edition 1971, second revision 1982.

Stearns, E.I. *The Practice of Absorption Spectrophotometry*. New York, New York: John Wiley & Sons, 1969.

Wright, W.D. *The Measurement of Colour*, fourth edition. New York, New York: Van Nostrand Reinhold Company, 1969.

Wyszecki, G. and Stiles, W.S. *Color Science*, second edition. New York, New York: John Wiley & Sons, 1982.

Illustration credits

Chapter 1:
Figure 1-1 modified from Eccles, J.C., *The Understanding of the Brain*, second edition, New York, New York: McGraw Hill Book Company, 1977.

Chapter 2:
Figure 2-1 modified from *IES Lighting Handbook*, fifth edition, J.E. Kaufman (editor), New York, New York: Illuminating Engineering Society, 1972.

Chapter 3:
Figure 3-2 after Dowling, J.E. and Boycott, B.B., *Proceedings of the Royal Society (London)*, B 166 (1966), pp. 80-111.

Figure 3-3 after Kuffler, S.W. and Nicholls, J.G., *From Neuron to Brain*, Sunderland, Massachusetts: Sinauer Associates, 1976.

Figure 3-4 after Jameson, D., in *Handbook of Sensory Physiology*, Vol. 7/4, Berlin: Springer Verlag, 1972.

Figure 3-5 after Brown, P.K. and Wald, G., *Science* 144 (1964), pp. 45-52.

Figure 3-6 after Boynton, R.M., *Human Color Vision*, New York, New York: Holt, Reinhart and Winston, 1979.

Figure 3-7 after DeValois, R.L., in *Proceedings International Color*

Meeting "Color 69," Vol. 1, Göttingen: Muster-Schmidt, 1970.

Figure 3-8 after Jameson, D. and Hurvich, L.M., *Journal of the Optical Society of America* 45 (1955), pp. 546-552.

Chapter 5:

Figures 5-8a and 5-8b after NCS promotion pamphlet, Scandinavian Color Institute, Stockholm, Sweden.

Figure 5-9 after Judd, D.B. and Wyszecki, G., *Color in Business, Science, and Industry*, third edition, New York, New York: John Wiley & Sons, 1975.

Figure 5-10 after Hunter, R.S., *The Measurement of Appearance*, New York, New York: John Wiley & Sons, 1975.

Figure 5-14 after Nickerson, D., *Color Research and Application* 6 (1981), pp. 7-28.

Chapter 6:

Figure 6-1 after Billmeyer, Jr., F.W. and Saltzman, M., *Principles of Color Technology*, second edition, New York, New York: John Wiley & Sons, 1981.

Figures 6-4 and 6-9 after Wyszecki, G., and Stiles, W.S., *Color Science*, second edition, New York, New York: John Wiley & Sons, 1982.

Figures 6-10 and 6-14 modified from MacAdam, D.L., *TAPPI* 38 (1955), p. 78.

Figure 6-12 after Applied Color Systems Inc., Princeton N.J., product advertisement.

Figures 6-16 and 6-18 after Wyszecki, G., and Stiles, W.S., *Color Science*, second edition, op.cit.

Chapter 7:

Figure 7-1 modified from Wyszecki, G., and Stiles, W.S., *Color Science*, second edition, op.cit.

Figure 7-5 modified from Richter, K., *Color Research and Application* 5 (1980), pp. 25-43.

Figure 7-7 after Pointer, M.R., *Color Research and Application* 6 (1981), pp. 108-118.

Figure 7-8 after Judd, D.B. and Wyszecki, G., *Color in Business, Science, and Industry*, third edition, op.cit.

Figures 7-11 and 7-12 after Alder, C. et al., *Journal of the Society of Dyers and Colourists* 98 (1982), pp. 14-20.

Chapter 8:

Figure 8-3b modified from Wyszecki, G. and Stiles, W.S., *Color Science*, second edition, op.cit.

Index